The Globe is a place to watch football (soccer). When there are no matches being played, it looks like one of many neighborhood watering holes where people meet, eat, drink, laugh, shed tears, talk sports, dance, and drink some more. And maybe then the name of the pub or being in a world city like Chicago wouldn't even matter.

But during a match, The Globe becomes just what the name says: the churning, whirling center of the universe where supporters from Munich and Milan, Glasgow and Guadalajara, Seattle and St. Petersburg, Barcelona and Birmingham, Norwich and New York, Capetown and Chicago—and, of course, Liverpool and Manchester—cheer, cry, chant, and curse, then pray that stoppage time will be enough for a miracle.

Michael C. "Chester" Alamo & Costello

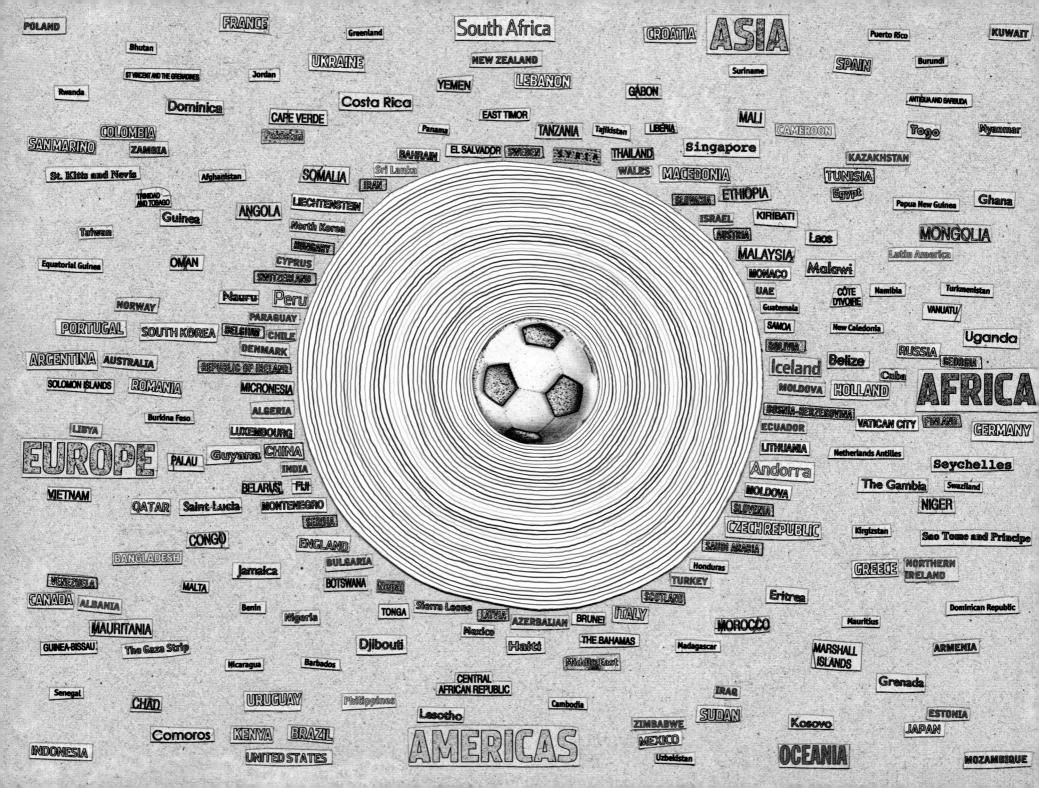

For all who enjoy a good pint before 9 AM with a touch of football.

# The Globe

Michael Christopher "Chester" Alamo & Costello

with essays by Jamie Michael Bradley, Sandra Kaminska Costello,
Aaron Patrick Flanagan, John Goodwin, and Jamie Hale,
and an afterword by Stuart Johnston

Chicago

## The Football Tapes

I first came to the United States in June 1971 and, being an Arsenal supporter, it was only natural to bring with me a couple of long-sleeved jerseys worn by that magical, double-winning side. These jerseys were to be given to future family members that were about to become (for a while) part of my life. A symbol of greatness as well as a fashion statement, that particular shirt is still my personal favorite; you know the one, solid red, white crew neck and white sleeves with red cuffs, and simply elegant.

Two years later I moved to the States permanently. There was little, if any, football to be had anywhere. A Mexican league game or a South American international on the local Spanish TV channel and an occasional Sunday newspaper clipping from either the *Mirror* or the *People* sent by my Mum were the only connections available to me. There was this giant gulf that made me feel as though I was truly on a different planet, miles away from being in the stands at some of those fantastic games at Highbury before they put the seats in. At Highbury you were literally swept off your feet when everyone's hands went up after a goal went in. When you look at old film from those days, the crowd looks like a sea of tall grass blowing in the wind. Now fast forward to the mid-seventies in Chicago and the experience of 3,500 people at Wrigley Field or Comiskey Park watching a baseball game that dragged on forever. I just couldn't see or feel the attraction of America's favorite pastime. Boy, was I aching for London's finest football club. When conversation touched on "soccer," I was constantly being told, "You wait, soccer is going to be BIG. All the kids are playing it!" I must have heard that line for almost a decade.

The mid-seventies did produce a great leap forward in audio technology, namely the cassette tape. Although I didn't realize it at the time, my Mum and Dad took advantage of that cutting edge technology. They owned one of those recorders that was a little bigger and bulkier than a VHS tape. It was simple to operate and came with a small microphone attached via a two-foot cord. In one of the storage cabinets in the basement of my house, there are perhaps eight or nine cassette tapes that have survived countless moves, unscrupulous people and, lastly, the death knell of all tape…fast-forward and rewind. I have been blessed because, not only are there some great games on these recordings, the background noise is priceless. These are the sounds of my Mum and Dad fumbling for the right position in front of the TV set or the radio after the "record" button was pushed, or the clattering of cups and saucers and clinking of spoons stirring the Brooke Bond tea and Express Dairy milk to the right color. This is the true magic of these tapes.

Take, for example, the recording of a match filled with historical and patriotic significance: an England v. Scotland game played on a damp mid-week night. With the crowd heard singing from the distant terraces in a capacity-filled Wembley Stadium, and with Denis Law as the color commentator, the magic of the match is broken by the sound of my dear old Dad trying—and failing—to stifle an Old Holborn–induced smoker's cough. He used to roll his own, and the stink from those fags drove me out of the house. Although I haven't listened close enough, I'm sure somewhere on one of these cassettes is his tin being opened and the rustling sound of Rizzla Red papers being rolled around the tobacco. There is the occasional small talk to be heard, but never understood because the tape recorder must have been within inches of the speaker of the TV set. Once or twice on these cassettes my Dad would get up close to the microphone and say hello, and that would be inaudible as well because the mike was cheap and nasty, resulting in only a loud, distorted "Hey, John." But to play one of these tapes today, and a rarity that is, I can close my eyes and be transported back to the living room of my youth. Smells, sounds, colors, objects; it's all there.

Thirty-odd years after moving to the U.S., I am truly amazed at the scope and depth and sheer availability of English football. I never imagined (but always hoped) it would reach this point. A point at which I am able to go to my local pub and be surrounded by people who not only talk like me, and grew up in or around London or have come from other footballing countries, but support the Arsenal as well! The Globe Pub is the ideal place to go to watch a game and to interact with, and snipe at, opposing fans. The cherry on top is when the fans at The Globe join in with the supporters in the stadium heard on the broadcast, singing along to a craftily-worded tune dedicated to the moment of play. Priceless.

John Goodwin

**An Essay Entitled, "The Globe Is (not) an Oasis." Or, "A People's History of (American Soccer in) the United States."**

I grew up near the banks of the Elk River along a stretch that runs east to west past Clendenin, pop. 1,116, and Elkview, pop. 1,182—two towns in West Virginia so small that most of America forgot it needed to remember to forget us. Soccer where I grew up, as in most largely rural states, was not widely played or even politely tolerated. The bad-ass good ol' boys I grew up with played football and wrestled. Even basketball and baseball were looked upon as, well, not necessarily the sports at which one might choose to excel. Which is a diplomatic way of saying that bigoted and nasty pieces of language such as "fag" and "pussy" usually followed any and all utterances of the word soccer.

As in many other regions and cultures, any form, action, or behavior reflecting weakness is held in deep, deep contempt and the instinct for exhibiting appropriate expressions of masculinity is assumed to have been injected into our bone marrow immediately post-birth. That contempt, even in its most glory- and testosterone-fueled moments, grew boring and redundant over time. And that contempt became one more reason why some of us outgrew our hometowns, our birthplaces, and all that we had learned and knew about the world during a particular period of time set in a particular place. Whether we felt forced out and headed off reluctantly, or whether we went willingly and fled at the first opportunity, doesn't matter. We all left some part of ourselves behind, there, in those times and those places. In this way, we move through each new world we enter as dichotomies—then fractals and beyond—of ourselves.

Soccer flickered dully somewhere out on the farthest edges of my peripherals when I was young. I played only one single season of organized team soccer. I was five, I think. Recently, people have begun to ask me, "what position did you play?" My answer invariably draws eye-rolling disbelief and/or pity: "What do you call the kid who sits on one of the penalty box Ds for the entirety of every match, picking his nose while swatting at flies, pulling the heads of dead and dying dandelion weeds, writing his name in the dirt repeatedly; a kid who preferred to do so over joining the circle of kids moving in unison, like a fluid school of mackerel knotted around the soccer-ball bait, over a sandy, lumpy field?" I was that kid, a kid who went on to play baseball for around ten years, whose junior high didn't even have a soccer team, and whose high school folded the soccer team's budget into the football team's and cut the whole program after its first and only season of existence. No one argued against cutting the program, though, least of all me.

My first ever meaningful soccer-watching experience, strangely, came during that team's single season of existence. Early one September or October morning, a voice crackled through our classroom intercom boxes requesting students to volunteer to be ball boys for that afternoon's in-school match between the Herbert Hoover Huskies, my school, and the South Charleston High Eagles. "In-school" meant the game would be played during the last two hours of the school day, so our entire student body would be attending the game rather than classes. "To volunteer" meant that I would be released from class even earlier than the other attendees. My hand shot up.

Looking back, the scenes of that afternoon mimic the contrast between what I did not know, at 13 or 14 years old, about the sport of soccer with what now, at 30, I've come to patiently and fervently internalize about the sport's history. The images of that afternoon remind me of the vast hemispheres of physical and figurative distance that sprawled out between me and the culture of the sport that now consumes me the way real tragedies and fictional romances consume others. It seems funny that here, in the previous sentence, only the word "and" is necessary to capture such distances.

Nearly all of our students, out of sheer boredom, had chosen to stand up along the ascending rows of rickety 2x10 wooden bleachers, which bowed beneath their feet. Some bleachers were as high as twenty feet above the more solid red-and-navy-painted support structures of cinderblock and mortar. The students stood all match long, too; perversely and stubbornly lining the home side of our football field like atheists furious over being forced to endure a seemingly infinite series of baptisms. During the game, teachers assigned to watch the stands broke up no less than three fist-fights in the bleachers and another two behind the stands. Just attending

the game itself seemed enough to flick the trigger safeties in the brains of those fighting to the *off* position. I bet not even the scrappers themselves knew what those fights were about, but I can guarantee you it had nothing to do with the game being "contested" before them.

I certainly didn't know what they were fighting about, as I was too busy traipsing up and down sixty yards of sideline after loose balls and stray passes (of which there seemed to be twenty-five million), desperately trying not to pass out, puke, and shit my pants (all at the same time) in front of my entire school. But I did know that no one would sympathize with my plight as a participant either; quite the opposite—hatred only maintains loyalty amongst the staunch ranks of haters themselves, after all. In thick, back-of-the-soft-palate, Elk River drawls, abuse was hurled continuously in thousand-decibel loads at each of the twenty-two players right from the kick-off. Raising the bile further was the fact that there had not been enough boys or girls willing to sign-up for our beleaguered, although brand-new, soccer teams. This forced our school's administrators to combine the squads, rendering the afternoon a mass flogging of our co-ed sacrifice by a team of wealthy, cocky white guys from the "big" city, all of whom had all grown up playing soccer.

It was, to put it crudely, fucking painfully awful in every way imaginable. I would compare it to listening to a tone-deaf, grade-school chorus sing ABBA's entire catalog on a continuous loop while being on the receiving end of a badly botched enema. Or maybe it's more accurate to describe the resulting implosion as having all the dazzle and charisma of watching, say, your neighbor from across the street fall and impale their crotch on a sprinkler head while furiously attempting to remove dog shit from their shoe by drunkenly stamping, grinding, and kicking their feet across a lush front lawn, which they themselves have just over-watered. You laugh. You joke. You, perhaps, cheer sarcastically. Most of all, you walk away with the realization that this pain will forever color your memory of the moment you've just witnessed.

Yeah, it was that bad. I promise.

Given our proximity to the event, the other ball boy and I were deeply scarred by the dire proceedings of that fall afternoon. While my leg muscles recovered in a few days, the emotional impact of those scenes clung to me like an ugly prom date. Not that I would know: I never went to prom and I didn't watch another soccer match for nearly two years.

Then came World Cup 1994, which brought with it the faux denim American-flag-emblazoned jerseys of the U.S. Men's National Team. At that point, I associated soccer at both the local and national level with some pretty bloody shades of embarrassment and revulsion. I thought the likes of Cobi Jones and Alexi Lalas looked like hippy jackasses—ah, that ugly conjunction of soccer and perceived weakness learned in childhood, conflated with the more recent cultural equation of hippy jackasses and everything un-manly (later in life, I would come to regard Jones highly; Lalas is still a jackass). This conflation was further reinforced by players from "other countries" who crumpled to the ground like they'd been sniped in the spine by heavy crossbow whenever anyone so much as tapped them on the shoulder. But then there were these two guys named Stoichkov and Dunga, who I watched intently, both seemingly willing to bite off their mother's ears if doing so meant victory. Then I noticed that, as far as I could tell, Brazil and Italy were good. And, when Baggio missed, oddly enough, I felt, well, bad.

Stranger still, I found what was a passing interest in the World Cup slowly morphing into an emotional attachment. Within a few years, I had begun to transfer the reverence I initially felt for Stoichkov's rabidness and Dunga's omnipresent power to the master and commander of the midfield, Roy Keane of Manchester United. I discovered Keane and United during one of those late-teen periods when a need to understand my sense of "self" in relation to my family's vanishing Irish heritage was part and parcel of an urgent need to figure out my own identity.

My family was forced from Ireland in 1790. For me, the familial connections that time and space have effaced are a missing space in my identity and a gap in our family's history. For years I tried to color in that blank space with any cultural means available to me—books, documentaries, films, art, poetry, and other media representations, which ultimately only reminded me of how little I will ever actually know. Today I'm left with the weight of what my family has lost but, for who and what they represented for me at 18

years old, Roy Keane and Denis Irwin put names and faces and personalities on the "Irishness" that helps to fill the gaps in my family's history.

My search for my family began to branch out and became a search grounded in some bizarrely collaged feelings that were, and still are, inherently and necessarily interwoven with football/soccer (the latter being an English, not American, sporting term, by the way). My search led me to look for something like a family around my family; that is, people who I could actually watch and talk about matches with and who, by the way, constantly led me into discussions that taught me about other cultures beyond Elk River.

Back then in southern W.Va., around late 1997, you could catch maybe an odd Dutch match or Champions League match on ESPN, but only during the most random and consistently un-advertised of time slots, which was frustrating. So I began seeking out matches or trying to, anyway. Not long after that, luckily, our cable provider picked up Fox Sports Pittsburgh. FSP would occasionally broadcast a full match but, every Sunday night without fail, they would broadcast a two-hour, MOTD-esque review show. The first hour consisted of highlights from the week's matches, while the second hour featured a condensed version of the "Match of the Week." For reasons I hadn't grasped yet, Manchester United was generally featured in the show's second hour.

Time passed and coverage intensified, my obsession intensifying with it, but I still had no concept of the place United held or of the desperate love and undying hate that the club's mere existence provoked. I'd seen photographs of George Best from his NASL days, but I had no way of linking him to United. I didn't know about Munich. Old Trafford looked big but, in America, all our stadiums were and are gargantuan (except for our soccer stadiums). I'd always had a feverish, innate penchant for commanding, ingenious team managers from any sport, so Alex Ferguson was easy to like. United had Keane and Irwin, of course, and I was beginning to learn that the club had been rather welcoming to Irish players during time periods when the Irish were otherwise generally unwelcome in England. A little later, I began reading books like Simon Kuper's brilliant work, *Football Against the Enemy*, which taught me, and Americans like me, of the extent to which the cultural fabric of our globe is actually woven by, not from, soccer/football. One of the few gaps in that fabric, interestingly enough, was in America. It occurred to me that I was attempting to fill a gap in my own family's history, in part, with a sport and culture that had zero presence in my country of birth; like a bird flying into a windowpane, misguidedly trying to fill one gap with another.

This past Saturday at 6:45 AM, for the first time ever, ESPN aired the first match of the 2009-2010 EPL season, Chelsea v. Hull City, live and in high def. This event was only monumental for those of us who have lived through the lean years of televised football/soccer in this country. I walked into The Globe after watching that match at home, immediately realizing that the immensity of the broadcast was only lost on those who have forgotten or never known that such extensive coverage was recently just a lottery, a dream. I was in The Globe the next morning at half seven for United v. Birmingham, cordially shaking hands and chatting with Alun, The Globe's resident City Brummie, and ordering my first beer of the day. Later, with Chelsea v. Hull still on my mind, I discussed the possibility of this essay with Chester. I realized, while talking, why I must write about The Globe. All of the matches that I watched from 1994-1999 share a single, sad trait: I watched them all, including all of the 1998 World Cup, and Manchester United's 1999 comebacks in Turin and Barcelona, *alone*.

In August of 2006, I moved to Chicago from Morgantown, W.Va., with one of my best friends, Jeremiah, and my partner, Aris, so I could attend graduate school at Columbia College Chicago. When I asked my Chicago friends where I should watch matches, they all invariably and instantly responded, "The Globe." When we duly arrived to watch the United v. Newcastle match, a balding gentleman with longish red hair put the match up for us on one of the flat screens in the northwest corner of the pub's back room and we ordered our first cold Old Styles. The gentleman checked on us every so often and, after stopping for the fifth or sixth time, decided to join us. As we would learn, he'd lived just about everywhere in the world and had definitely enjoyed himself along the way. While he downed pint glasses of Captain and Coke at an F-1 pace, we learned that he'd actually played soccer for Cambridge City so he could earn some extra cash in college. At some point

he started buying our rounds, while speaking of his familial love of Celtic FC, long-ago-yet-ever-present trips to Parkhead, and his father. We learned about the pub's regulars and the resident supporter's groups. And, eventually, we learned that his name was Stuart and that he was the co-owner of The Globe, along with someone named Jamie.

What we also learned is that when your hosts don't feel the need to explain to you the full extent to which you are truly a visitor in their space, when they don't waltz over to you like king-shit and proclaim themselves the establishment's cultured proprietors, when instead they simply allow their individual spirit of generosity to show you that it's okay to feel at home even when you're so clearly not, you should be immensely thankful. Some might say Stuart was simply securing two fresh, potential regulars, but I don't know. I do know that I have since seen Stuart welcome so many others in that same fashion, with drinks and a long chat in the stained hardwood dimness of The Globe. And I've stuck around since that night because Stuart didn't dismiss me for being guilty of following an EPL club even though I wasn't born there. Or because I was an American who suffered, perhaps rather typically, a moment of verbal brashness by stating that "You'd be surprised. We know our shit, more than most Americans." Or something arrogant and off-putting like that; something ironically and purely born from a desire to connect with other ardently wild football/soccer supporters.

Whether its within five minutes or five hours of meeting you, no one wants to hear why your opinion about football/soccer—or your opinion of anything, really - is particularly valuable. After that night spent talking with Stuart, I have tried, in all areas of my life, to remember to talk a little less and to just shut the fuck up and listen. What we might know about football/soccer, what matches we've seen or heard, and what grounds we've visited or missed out on, pissed on, sang on, and/or fought on can't matter. Whatever authenticity we believe our nations and cities of birth bestow or bequeath upon us can't matter. All those days and nights spent on buses and trains and planes just to get to matches, all those thrills and terrors, those goals and missed penalties, blown or lucky calls, terrace songs and chants—when I place them all alongside the only stadium I can claim I know (Toyota Park) and the only supporters' group I can claim I belong to (the Whiskey Brothers Aught Five), none of it can or will mean anything until we've listened to one another's stories. Our minds and memories alone don't give this sport meaning, our lives do.

One warm Saturday afternoon early in spring 2009, I was sat talking with Martyn, a fellow United fan who hails from England, and Stephen, a United fan who spent his first twelve years of life in Cobh, Co. Cork (hometown of one Roy Keane). The day's matches had run their course, but the pub was unusually vacant and quiet for such times. Erin was carting us drinks from behind the bar, cause she's good like that, and after a period of disjointed rambling our conversation settled into a more sincere tone, like a needle into the threads of your favorite LP. Serious pub dwellers are beautifully addicted to such moments of alignment, and we immediately fall into them, willfully, as they happen.

Martyn began recalling a holiday he'd ventured on back in his early twenties, despite the stern warnings he'd received from his Mum, to Northern Ireland. Martyn spoke, as he often does, of drinking on the way to meet women. Being the skilled raconteur that Marytn is, he touched on the especially hilarious and tastily explicit, but his attention to detail and choice of words began to sharpen—no mean feat considering how drunk we were—as he began describing the bleak omnipresence of security forces, RAF troops, and the PSNI, as well as their weapons and attack dogs on taut leashes. He vividly detailed the barricades he'd seen and crossed, the security vehicles, the faces of the uniformed men, young and old, beneath helmets and visors, the pat-downs and searches, and the pangs of paranoia that seized his friends during such times. Martyn laced the story, however, with ardent testaments to the generosity total strangers had shown them during their journey. All at once, Martyn's story sounded overwhelmingly familiar; as if he had plucked it all from the photographs and pages of the Tim Pat Coogan books I had pored over during my late teens and early twenties.

Martyn's story was a fantastic yarn, which I will not insult by attempting to reproduce here in any more detail than I just have. Its affect lies in the past, inside the three of us who surrounded that high bar table, in that particular moment, in that particular place and space. Steve then picked up the thread of the conversation. A twenty-something Irishman and a forty-something Englishman continued to speak openly, for hours, about those times of trouble, their grandparents, their hometowns, their parents, friends, and friends of friends. Then came more and more stories, stories within stories; all with tones as sincere as they were candid. I listened and learned so much from the pair of them that day, I would like to take the opportunity to thank them now.

What resonated deepest with me, though, was the weight each of them seemed to be carrying: the weight of their respective senses of longing for somewhere, some place, some time, and the people gone or still residing there; the pies, the pints, the street lamps and cobbled corners of such familiar haunts; every syllable too human to be cliché. What I learned that afternoon was this the gaps in their own personal histories were akin to my own, and we had begun discussing such weights because of football/soccer, because of The Globe.

Which is why it would have been too reductive and predictably trite if I were to have begun this essay with a sentence like, "The Globe is an oasis"—or anything bullshit like that. The Globe is a pub, period. Okay; insert intensifier: The Globe is a football pub. Yes, obviously. But The Globe, for so many of us, is more akin to a dwelling of sorts, one which each of us defines and details and delimits according to the weight we carry. Some of us will never dwell in the grounds we loved because the grounds are gone, as is the case for my fellow Whiskey Brother, Tom Dunmore. The Goldstone Ground, where his dad first took him to see Brighton and Hove Albion play, was torn down in 1997. The Globe allows ex-pats, like Tommy, to move as close together as possible in order to allow the scenes that fill their memories to be spoken of and to accumulate, like so many thousands of threads in a fabric,

like the weight of so many gaps in so many personal histories. The Globe also allows those of us who will never stand on such terraces to learn about those places and those people from those who knew them truly.

If this is true, then a dwelling is a space that we carve with the power of our lungs, not just our hands or our minds. Oxygen fuels more than fire—it propels our stories. Our screams (whatever other emotional purpose they may serve), like our scarves, are nailed firmly into the walls of The Globe. Just like our bar tabs and our livers, our anguish and our elation, our conversations and our stories—all of them—they are all manifested vocalizations of the pure space that The Globe occupies for so many of us.

Chester's photographs are the visual document of our vocalizations; our vocalizations caught in mid-flight.

For me, this sport of soccer/football, which The Globe exists to serve, offers so many of us the chance to satisfy the deep need to seek out, to access, and to realize our own connections to our own immigrant histories, as well as those of others. However distant and faded or present and vividly affirming these histories may be, however rooted in our imaginations our connections may be, it matters not because we all care immensely about this sport. And caring immensely has rendered our connections just as real as our affections for our clubs and our cities and nations of birth—however near and far they stand apart, however we may stretch to connect them. The Globe helps this be so.

Aaron Patrick Flanagan

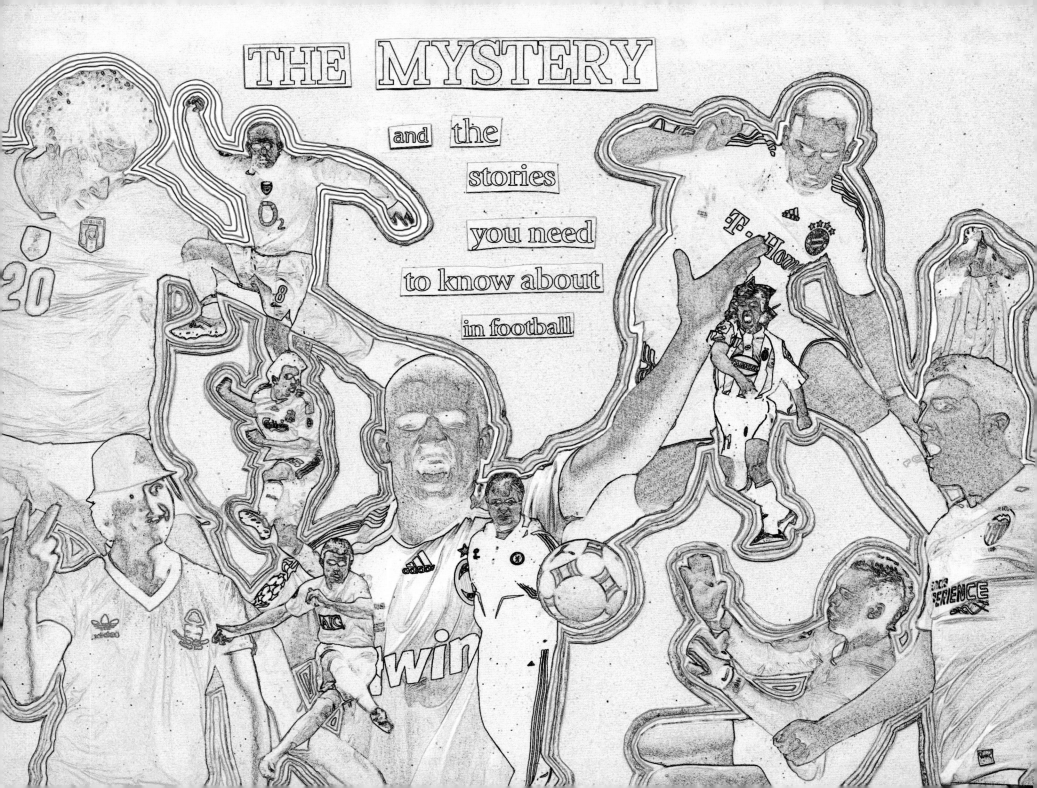

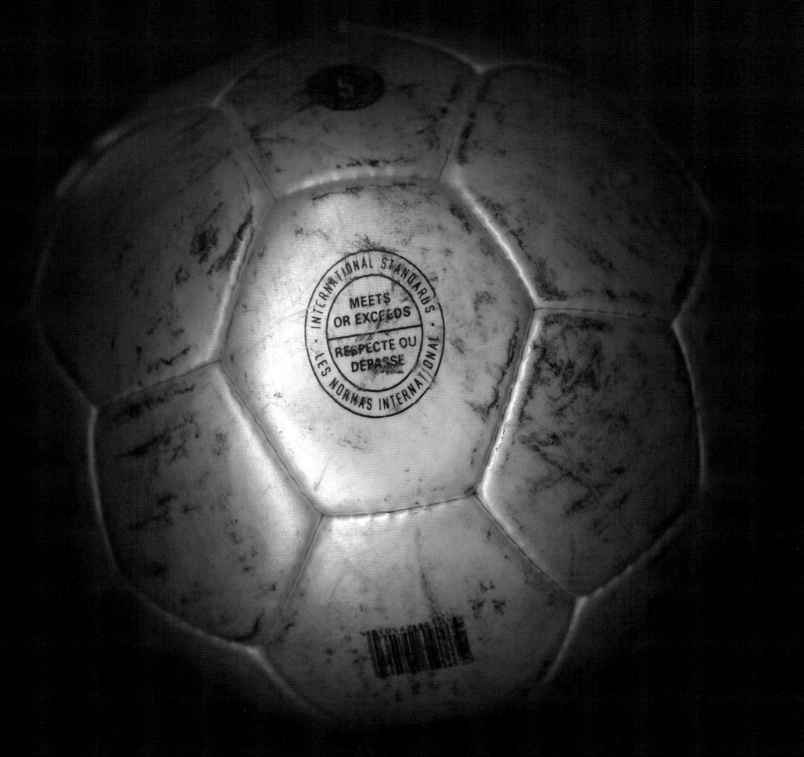

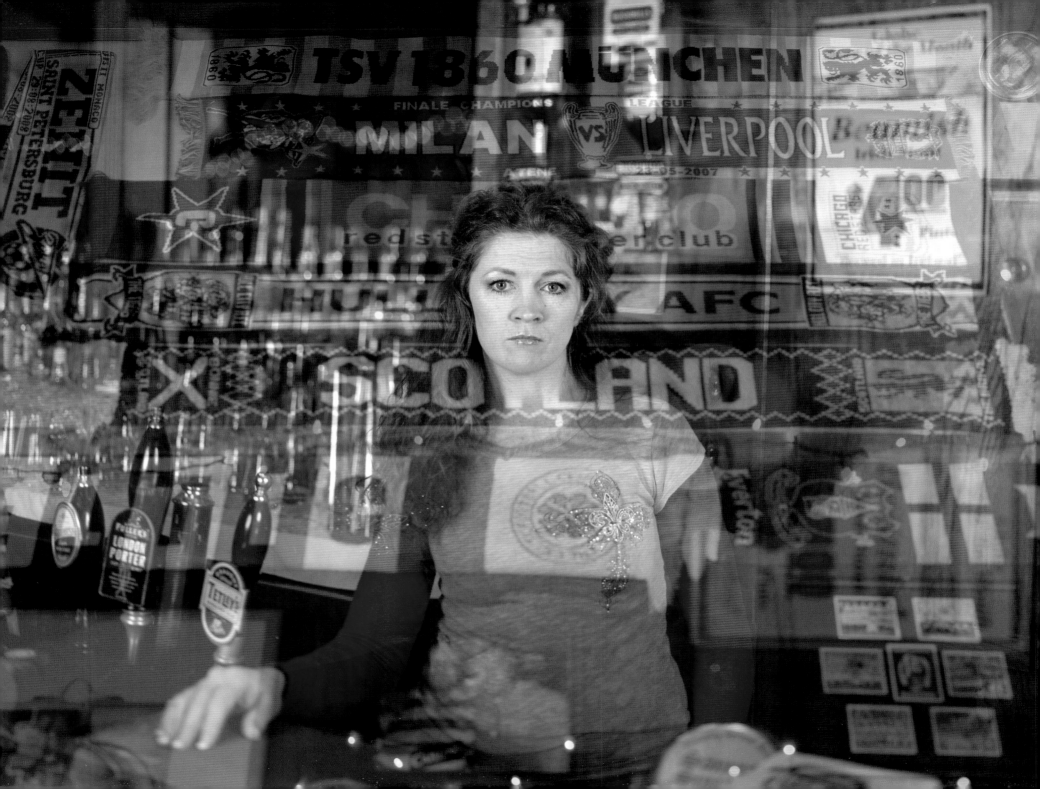

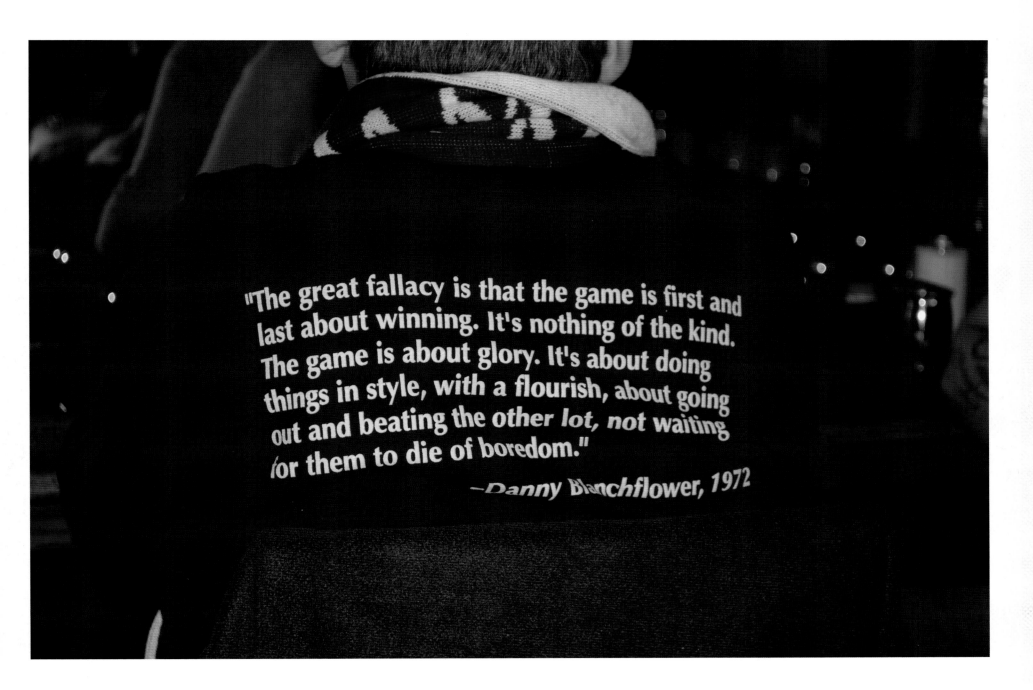

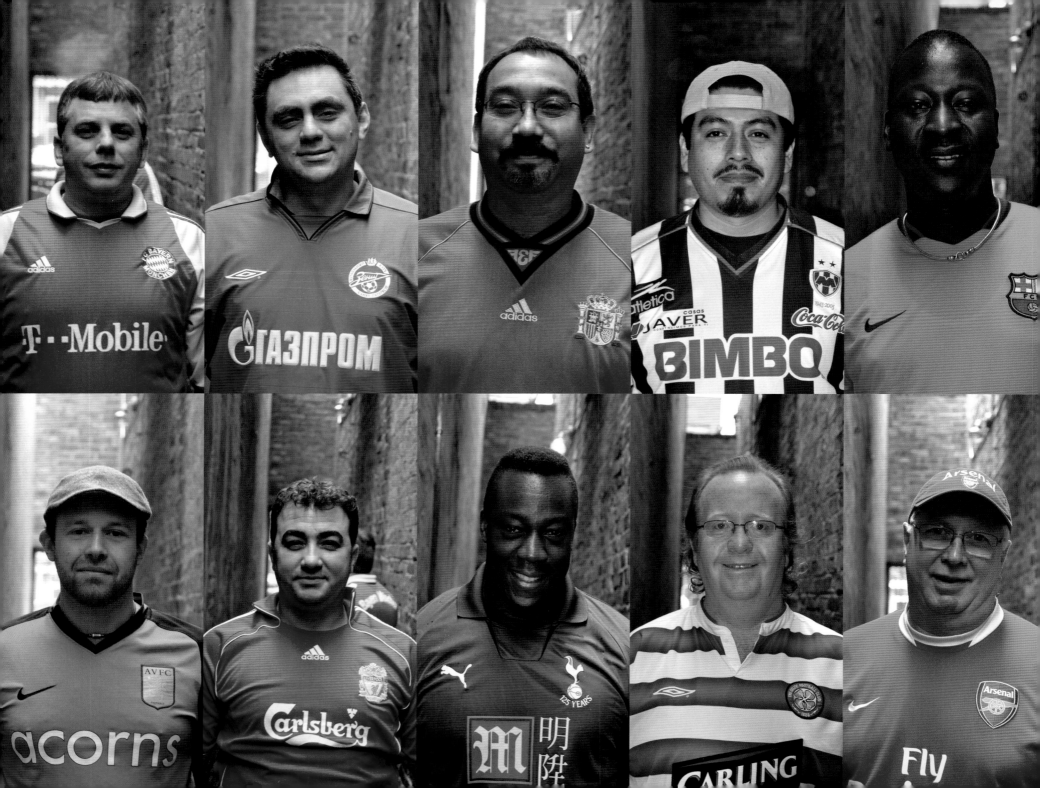

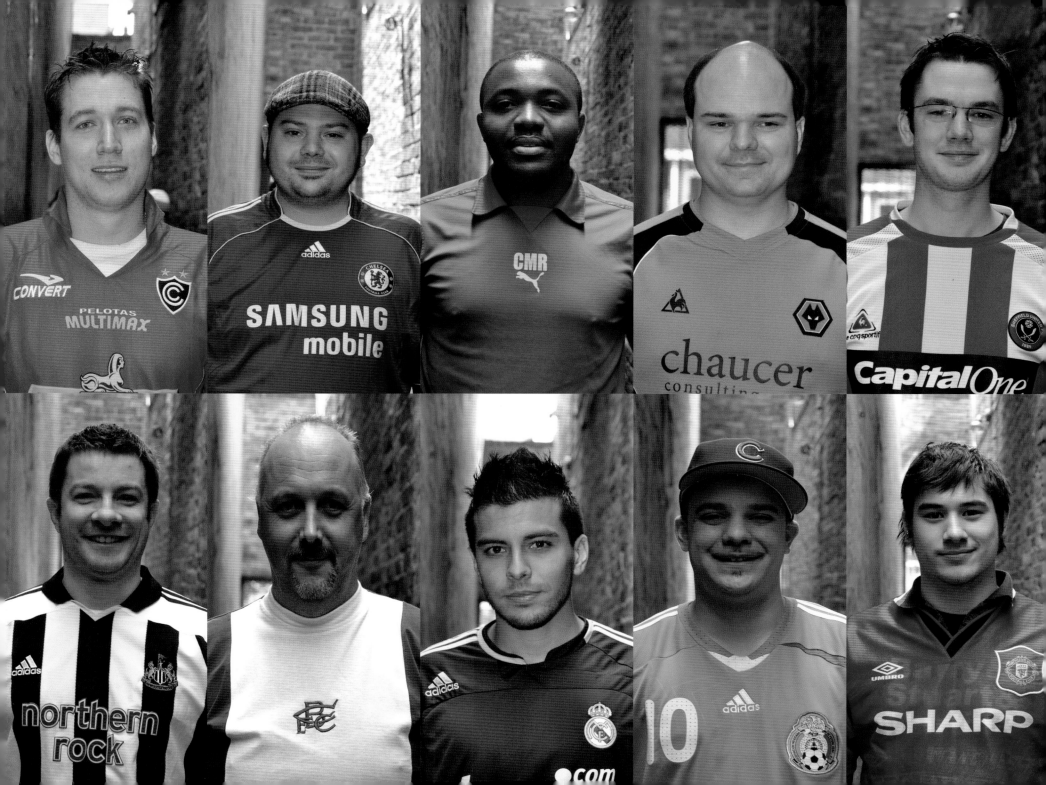

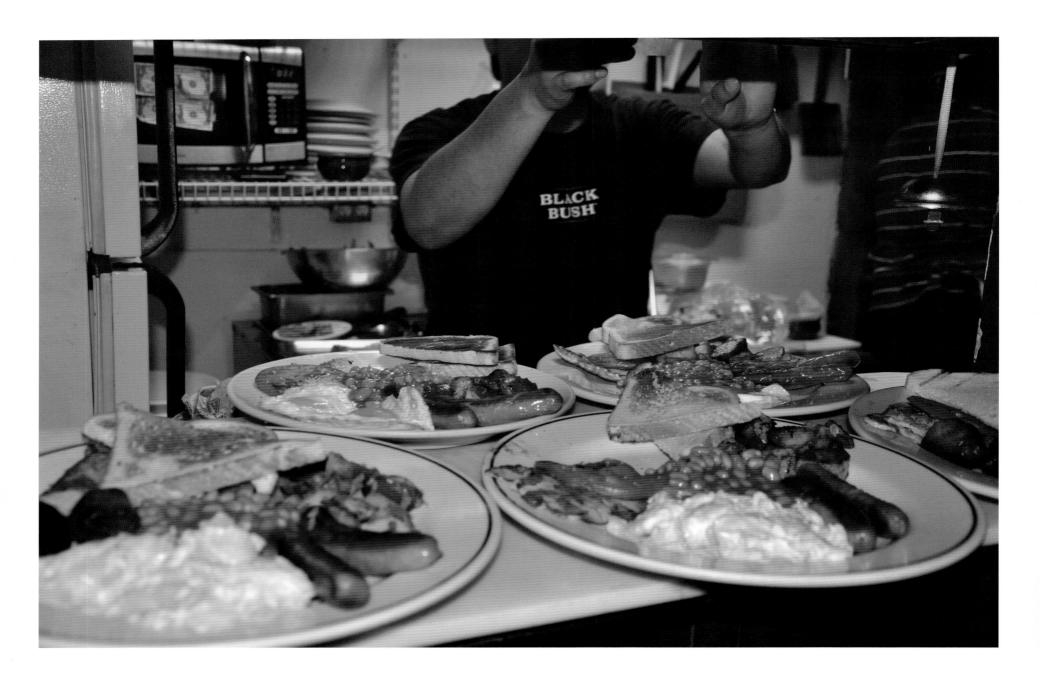

| | | |
|---|---|---|
| MLS | DC United v FC Dallas | 6.30pm |
| MLS | FIRE v Sounders | 7.30pm |
| IBO Boxing | Ricky Hatton v Manny Pacquiao | 8pm |
| MLS | Rapids v Real Salt Lake | 8.30pm |
| MLS | Galaxy v Red Bulls | 9.30pm |
| MLS | Earthquakes v Chivas USA | 9.30pm |
| AFL | Melbourne v Geelong | 11pm |

**Sunday 3rd**

| | | |
|---|---|---|
| Championship | Crystal Palace v Sheffield United | 7.15am |
| Championship | Reading v Birmingham City | 7.15am |
| EPL | Liverpool v Newcastle United | 7.30am |
| Serie A | Catania v AC Milan | 8am |
| Heineken Rugby | Cardiff v Leicester | 9am |
| EPL | Sunderland v Everton | 10am |
| Serie A | Genoa v Sampdoria | 1.30pm |
| Ligue 1 | Bordeaux v Sochaux | 1.55pm |
| WPS | Washington Freedom v St Louis Athletica | 5pm |

**Monday 4th**

| | | |
|---|---|---|
| EPL | Aston Villa v Hull City | 2, 7pm |

**Tuesday 5th**

| | | |
|---|---|---|
| Champ League | Arsenal v Manchester United | 1.45, 7pm |

**Wednesday 6th**

| | | |
|---|---|---|
| Champ League | Chelsea v Barcelona | 1.45, 7pm |

**Thursday 7th**

| | | |
|---|---|---|
| SPL | Hearts v Hibernian | 1.45, 7pm |

$20 co

23

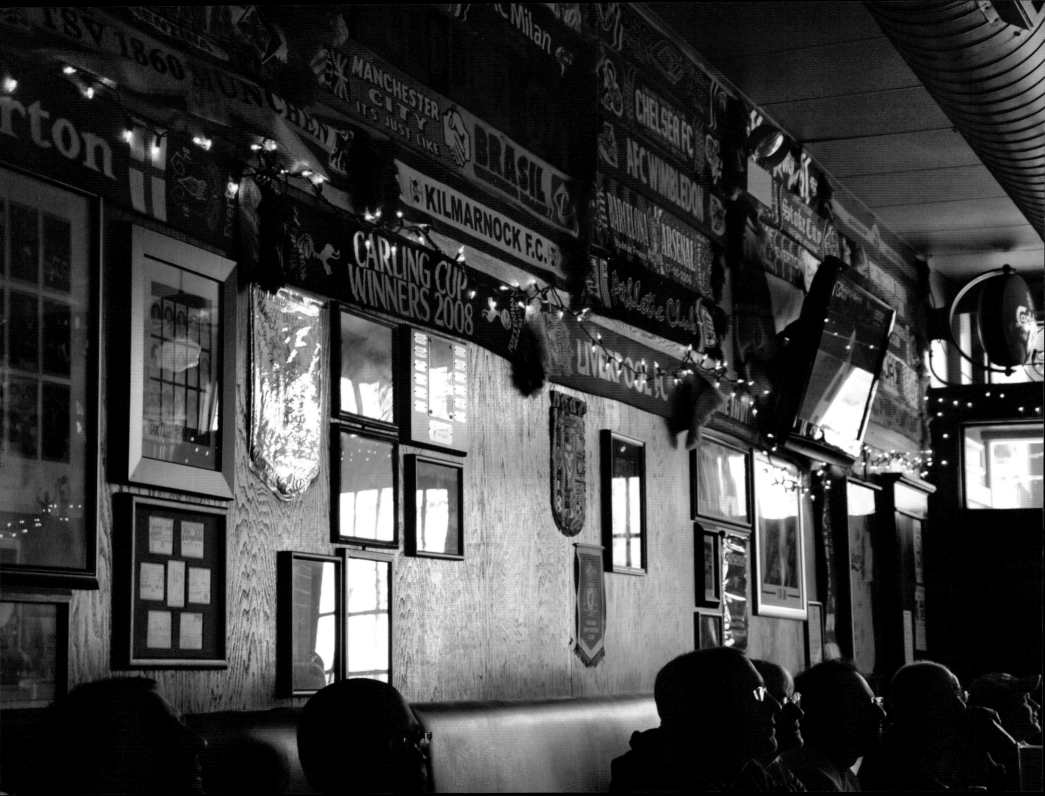

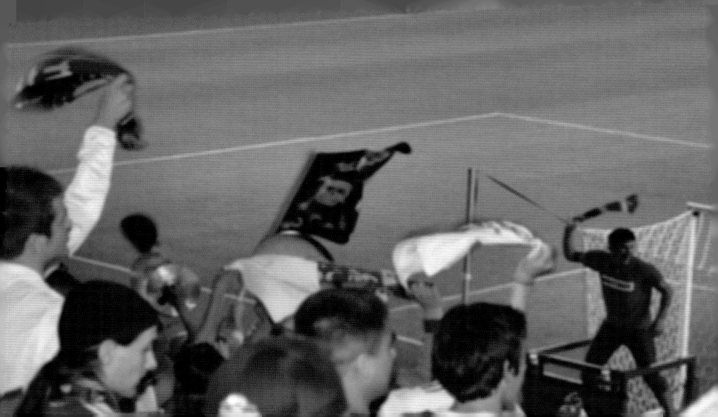

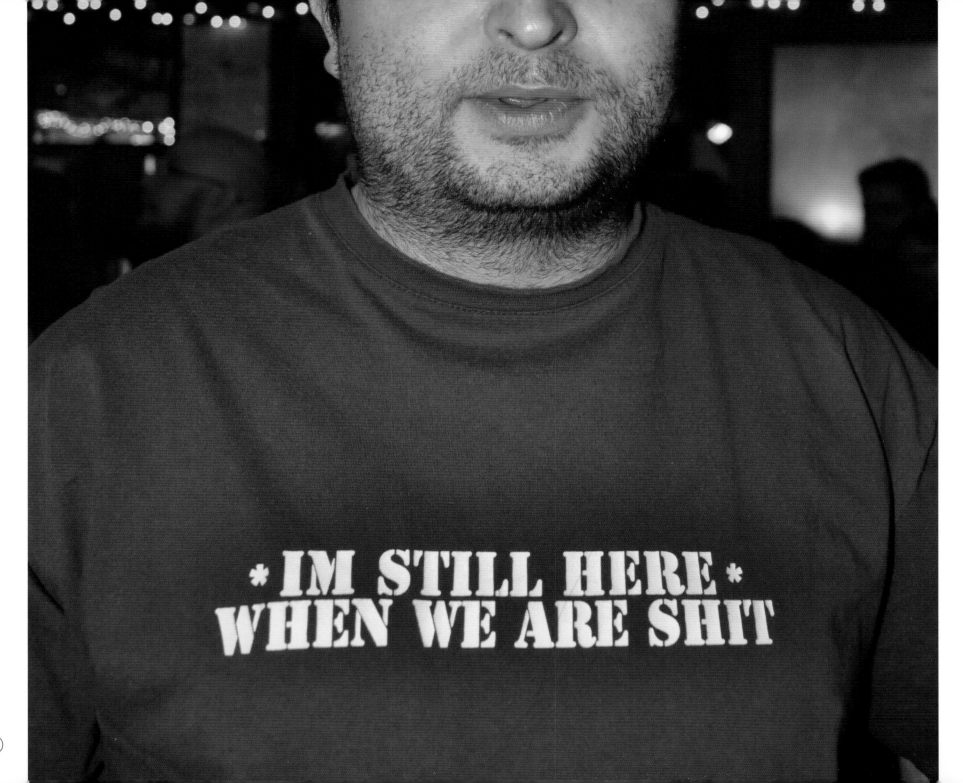

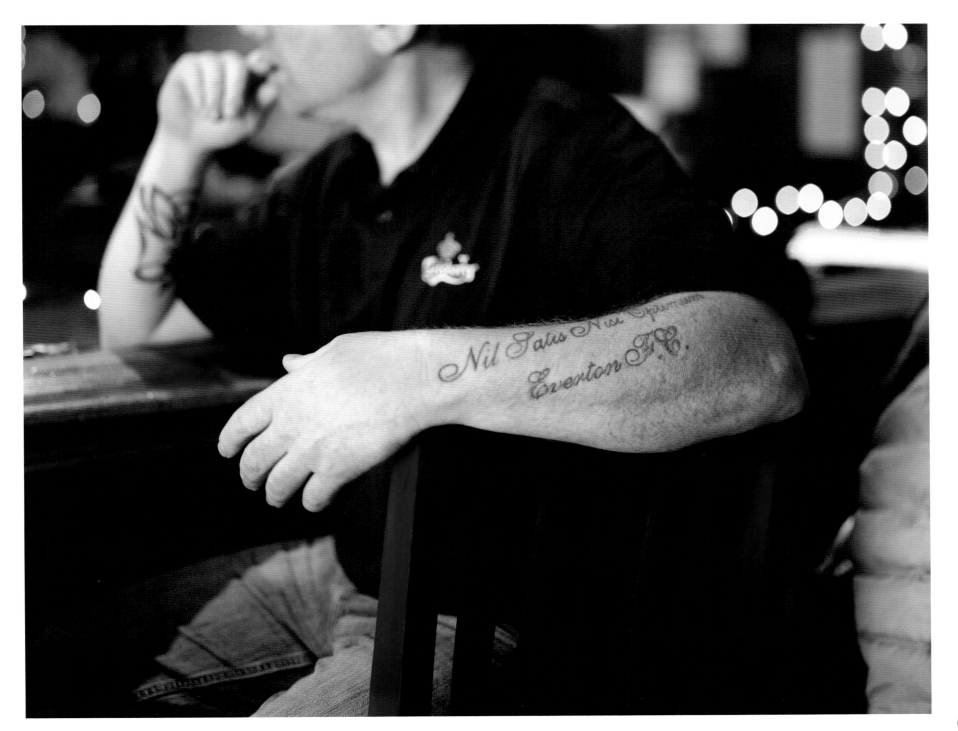

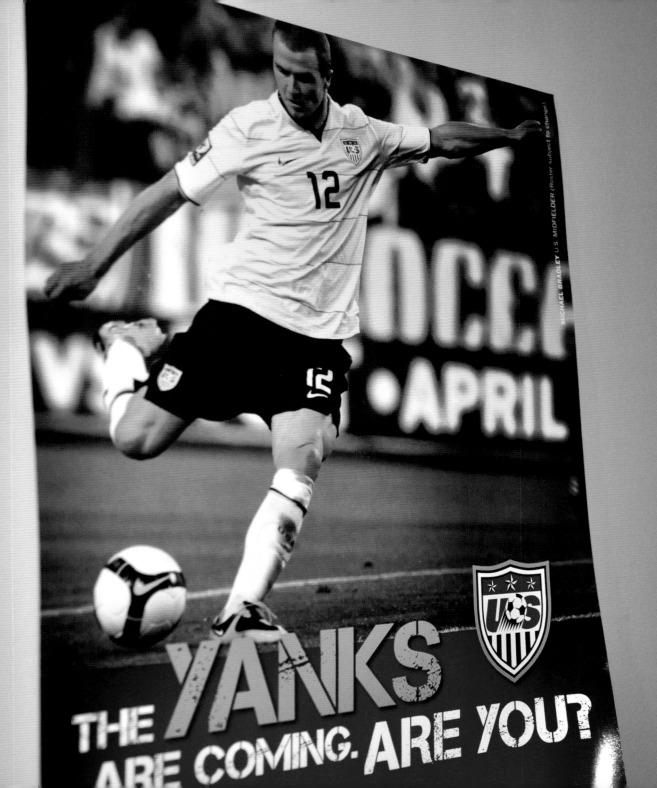

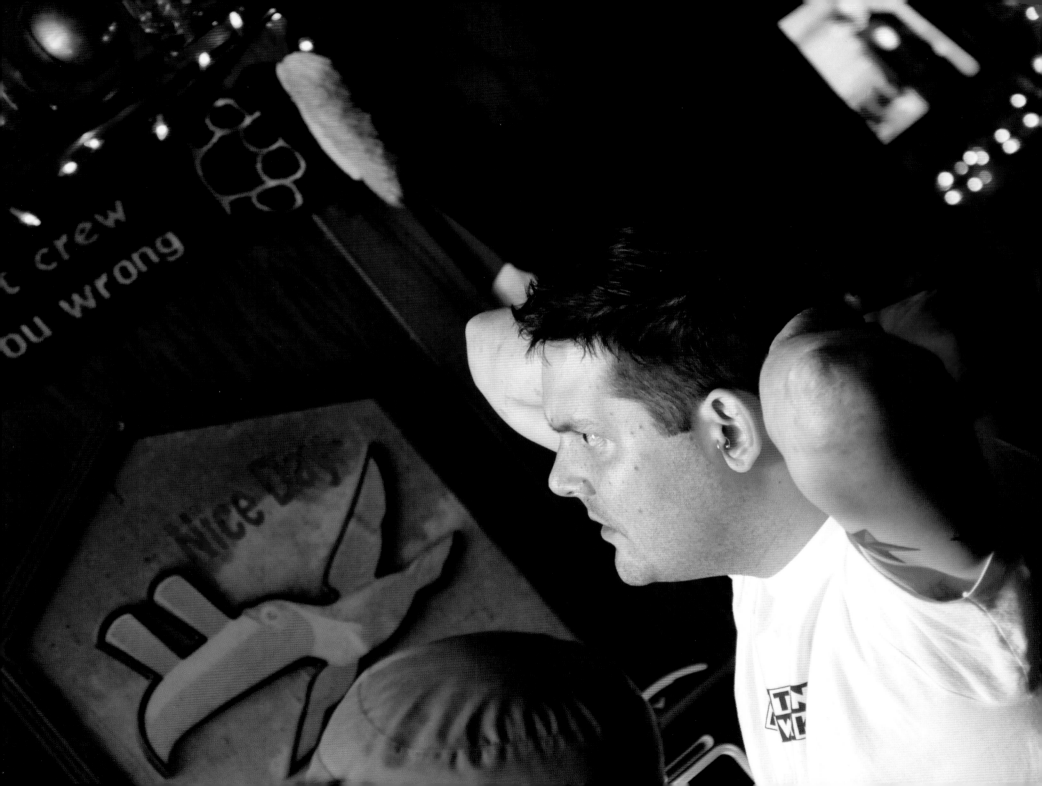

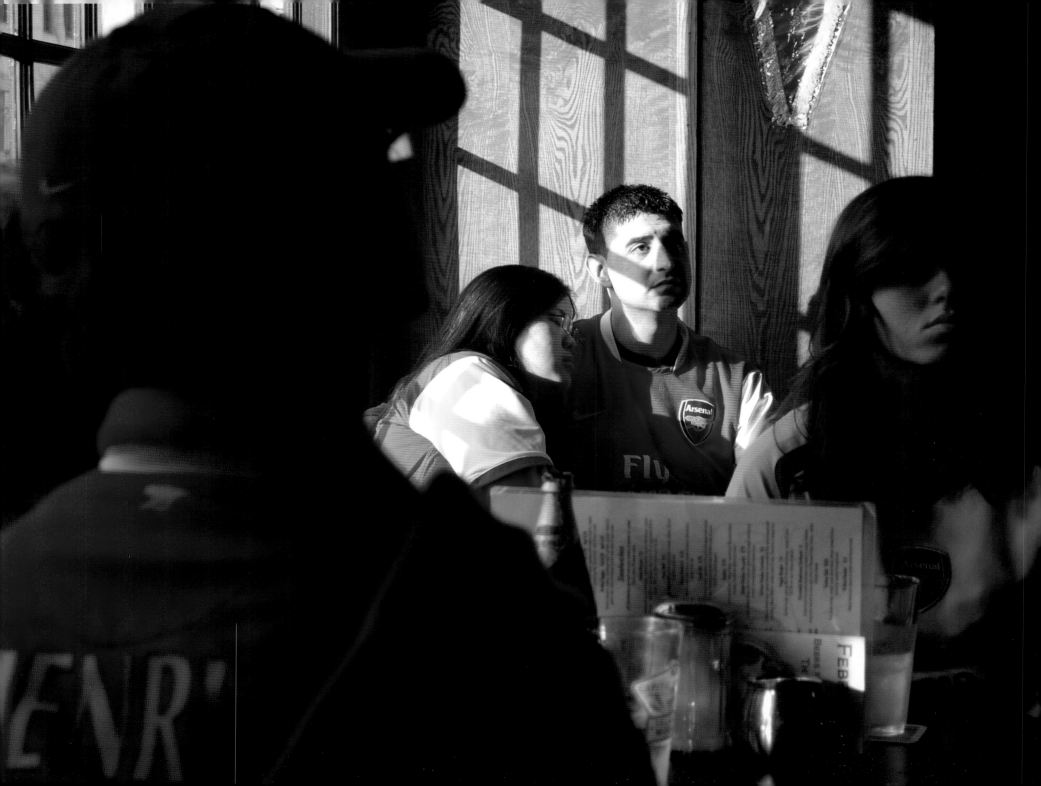

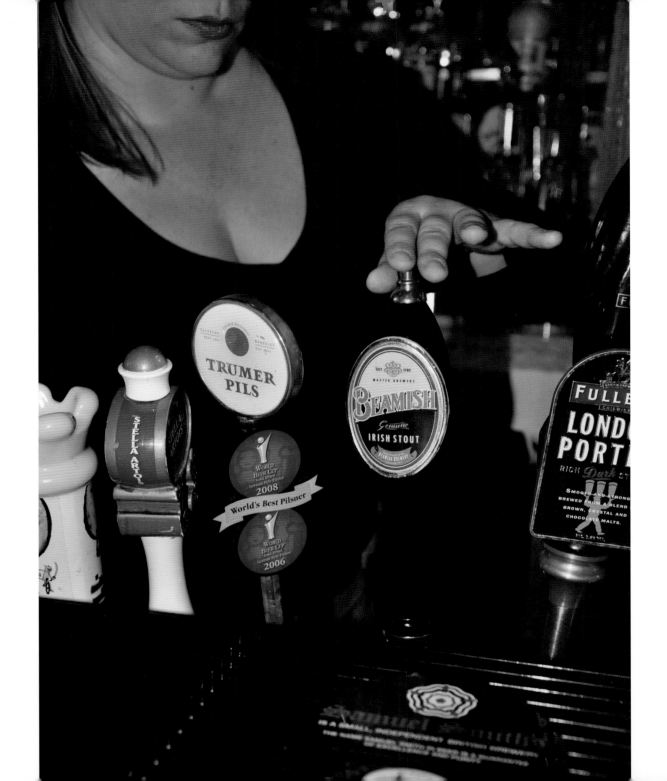

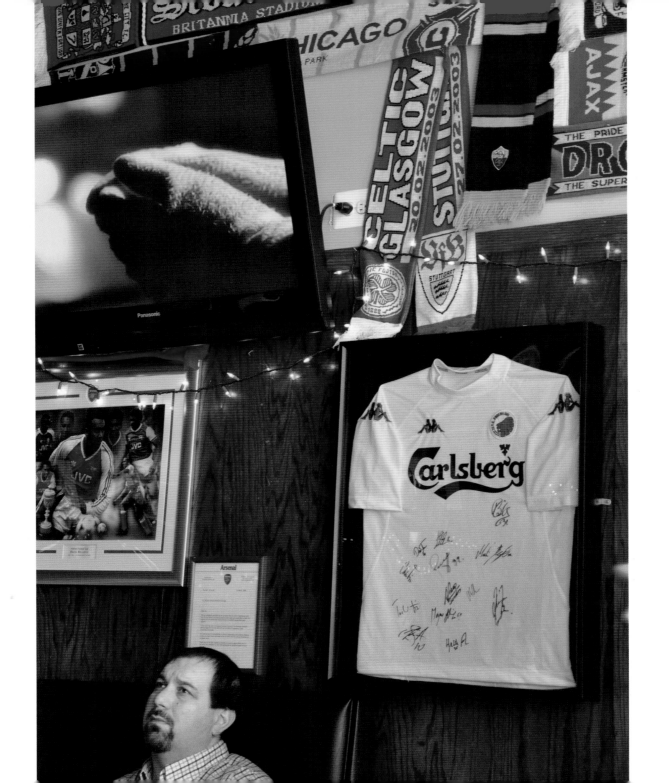

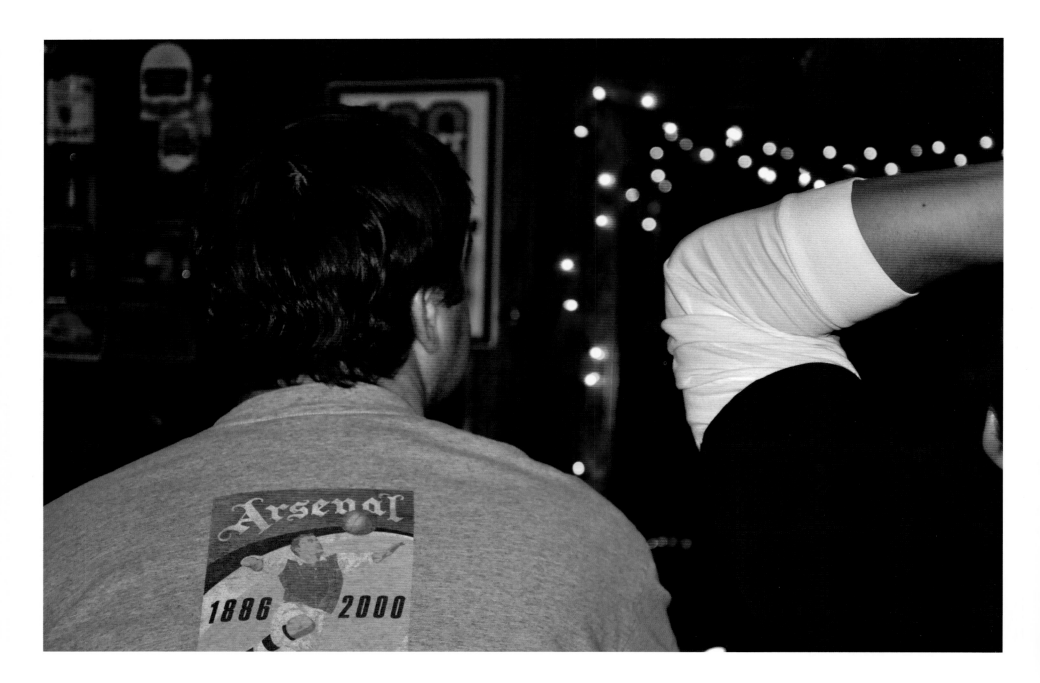

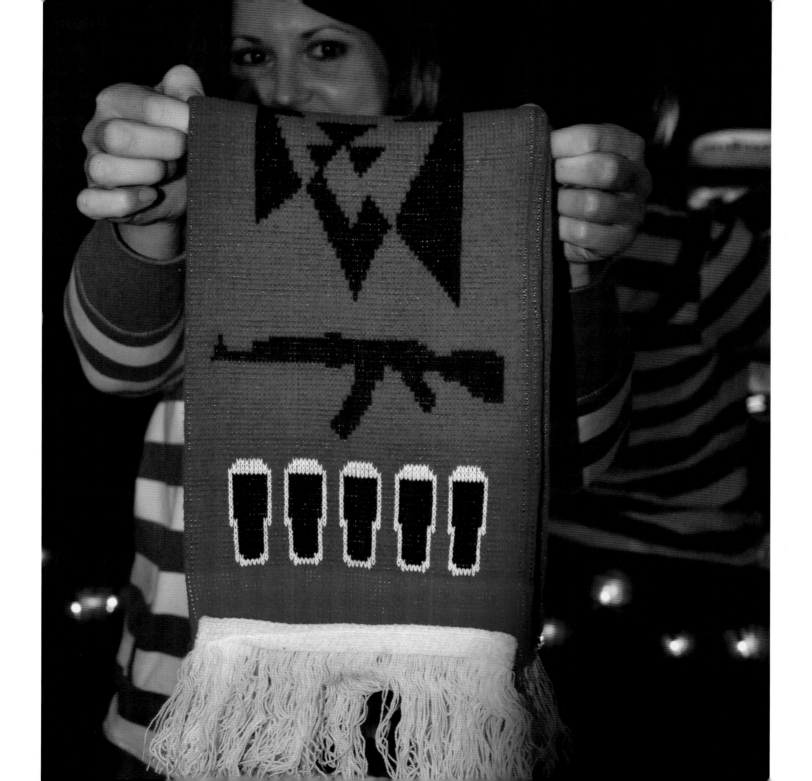

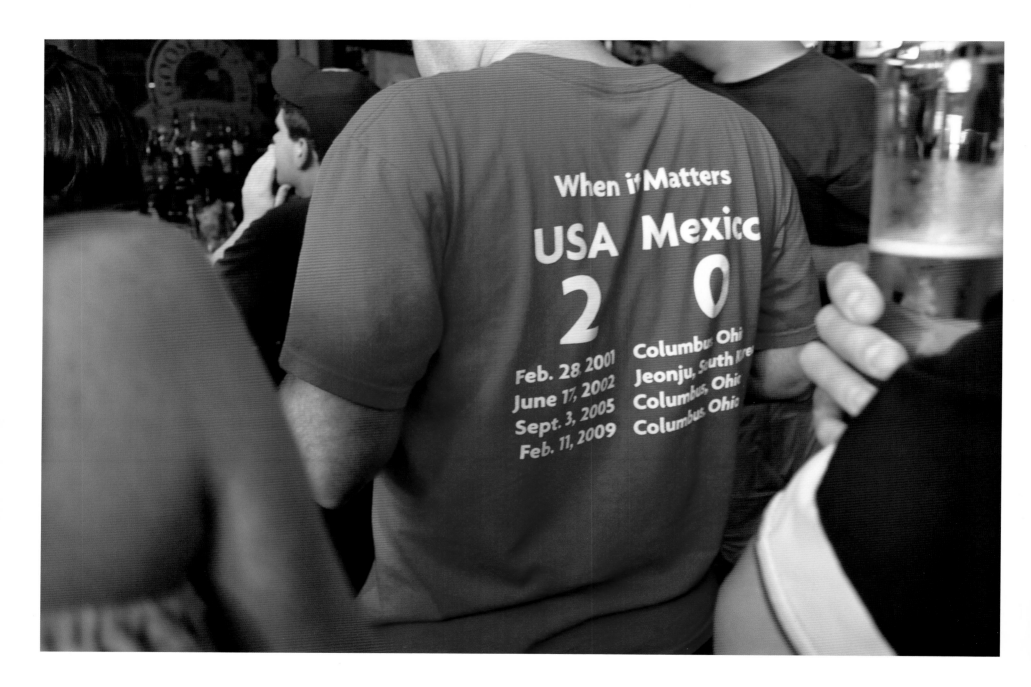

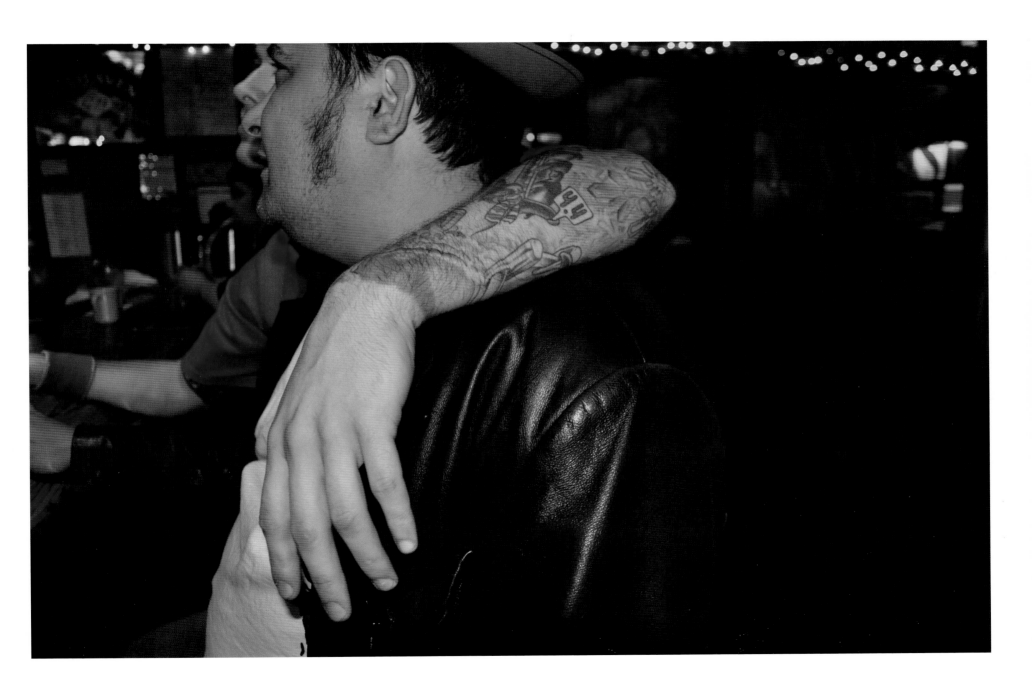

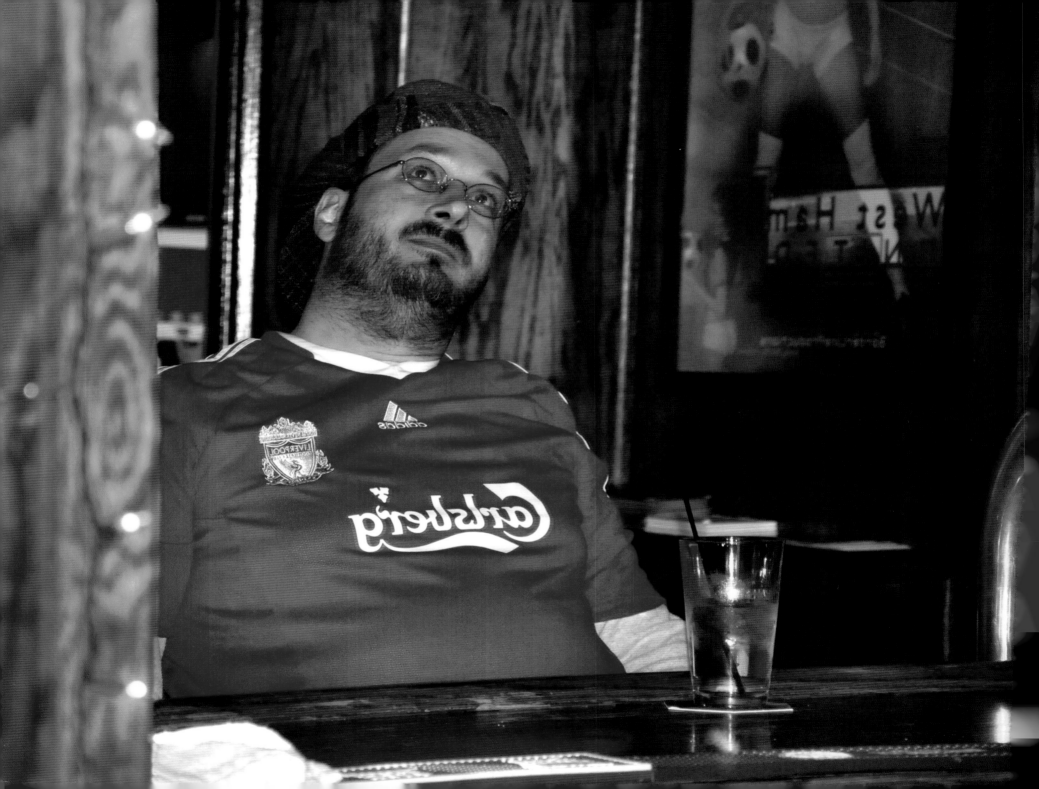

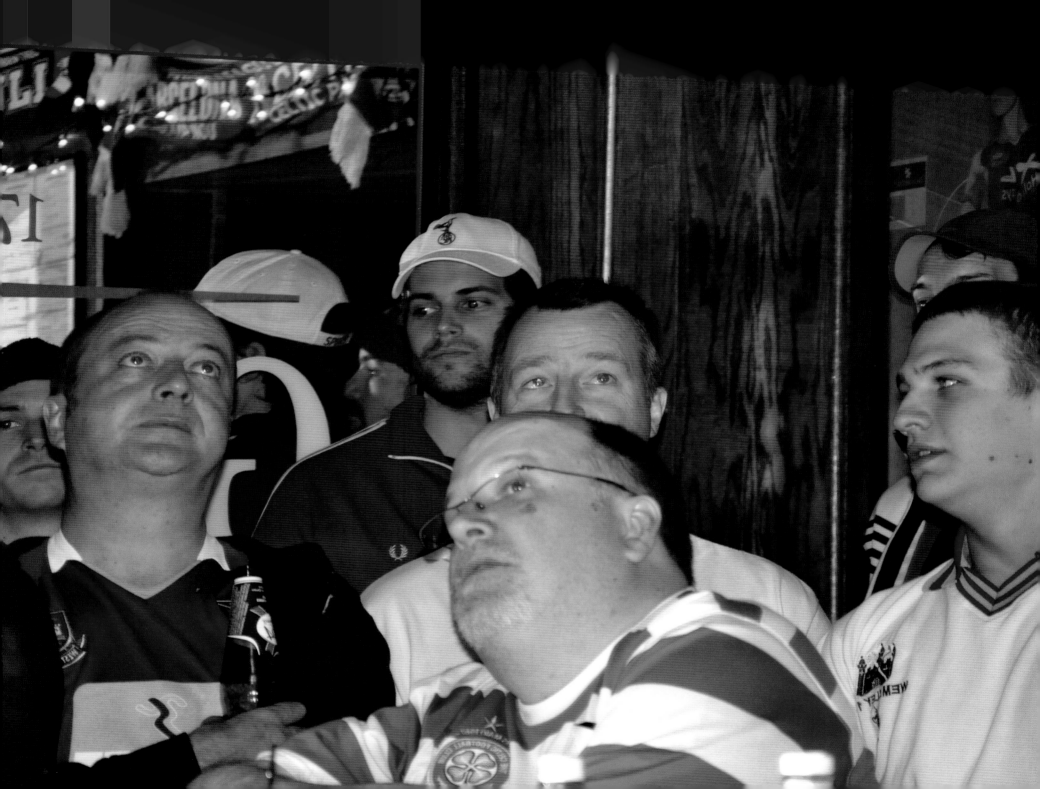

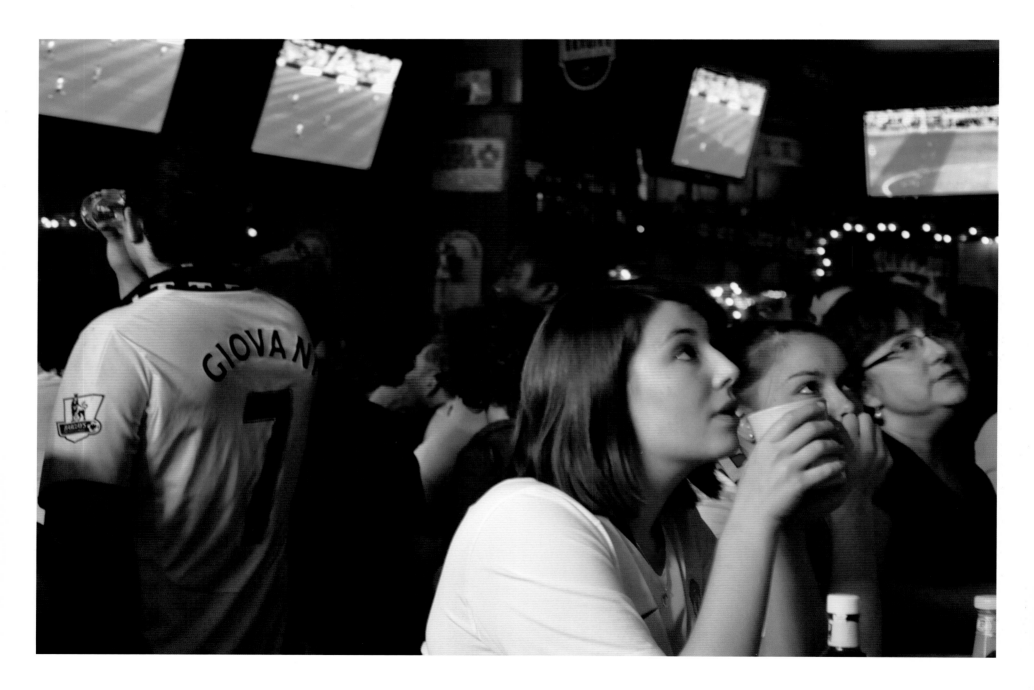

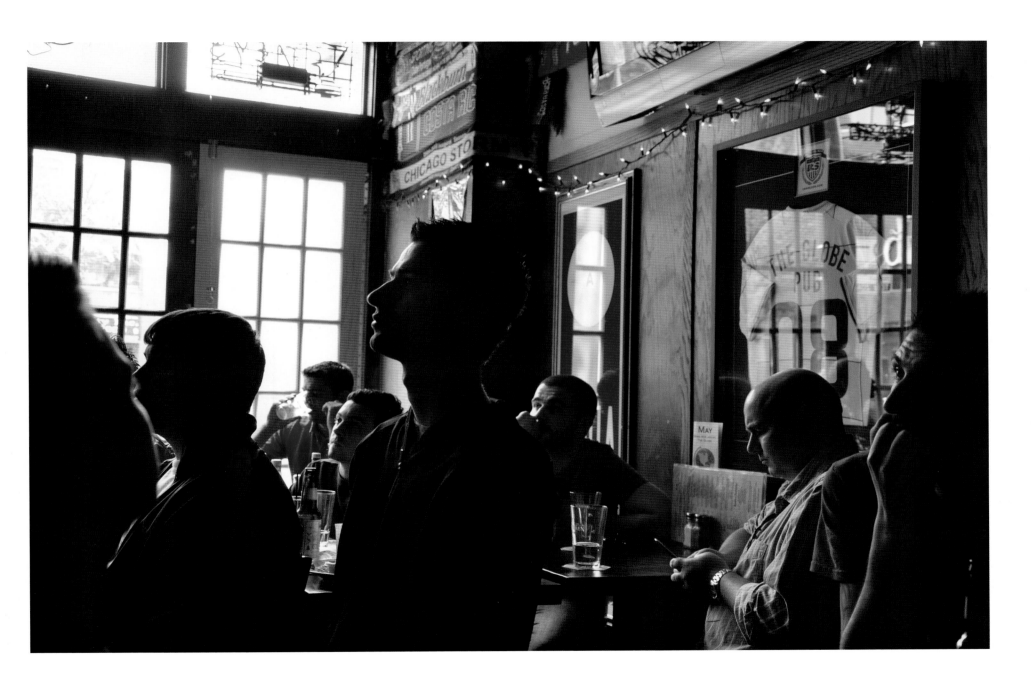

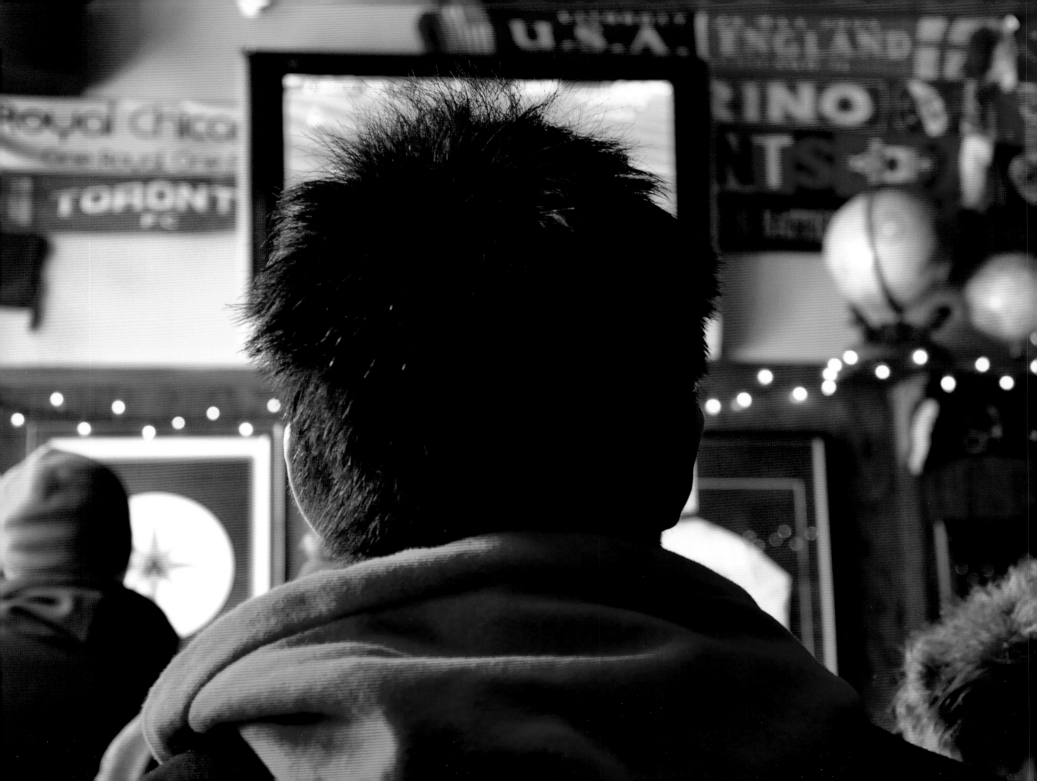

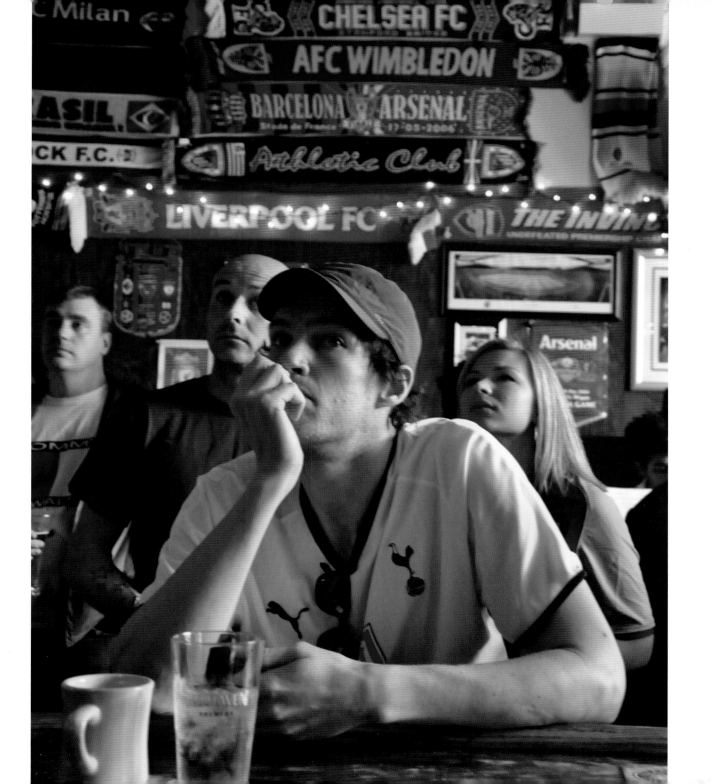

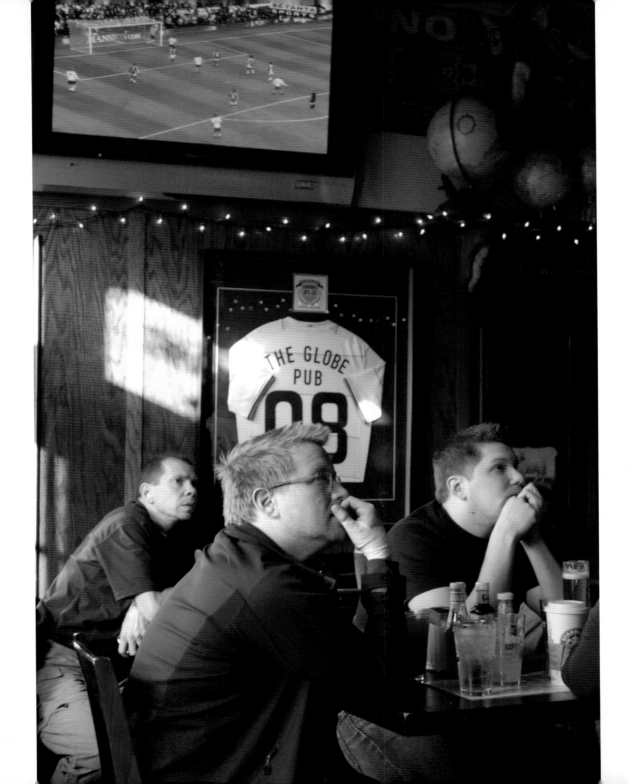

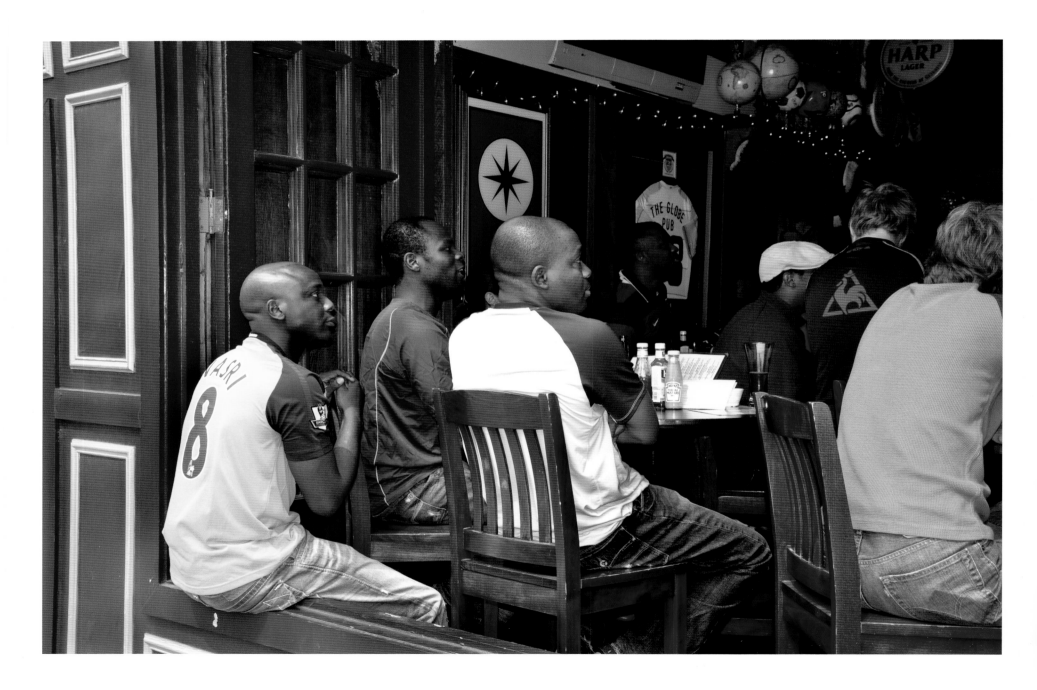

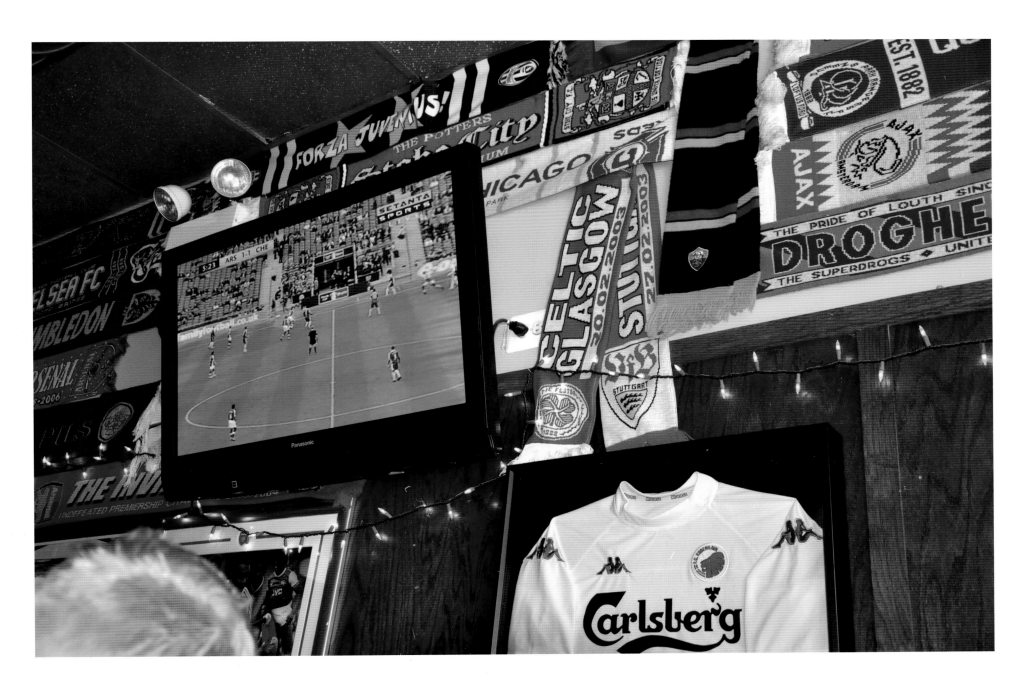

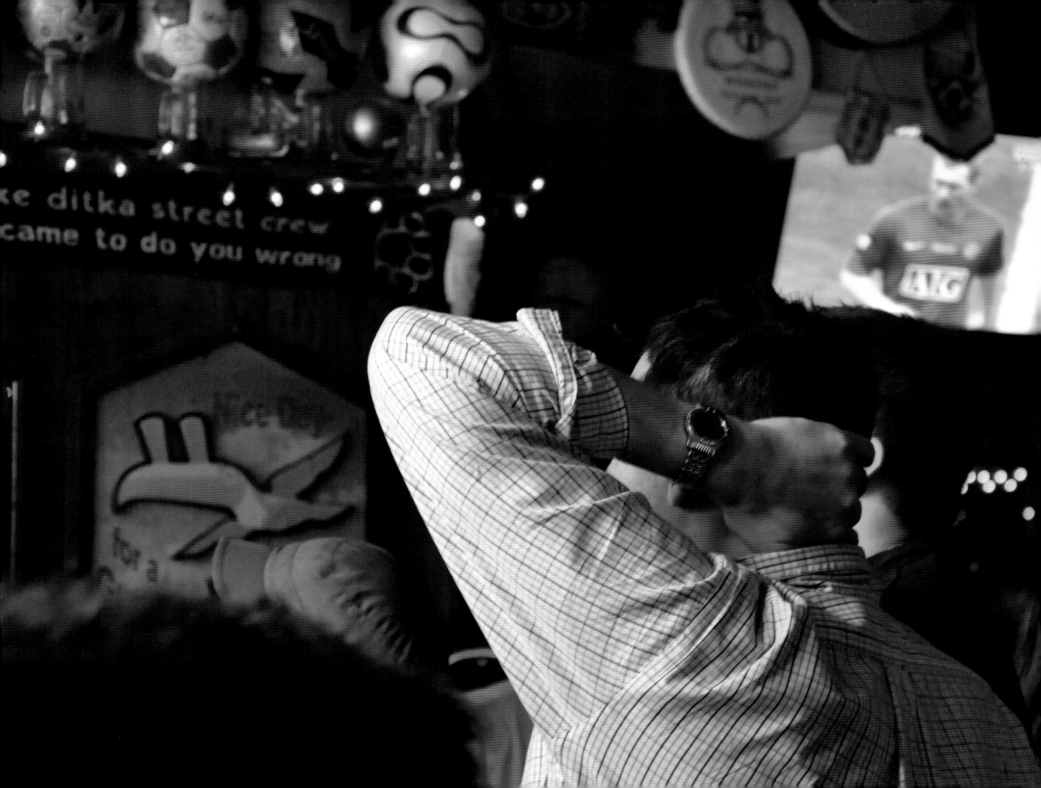

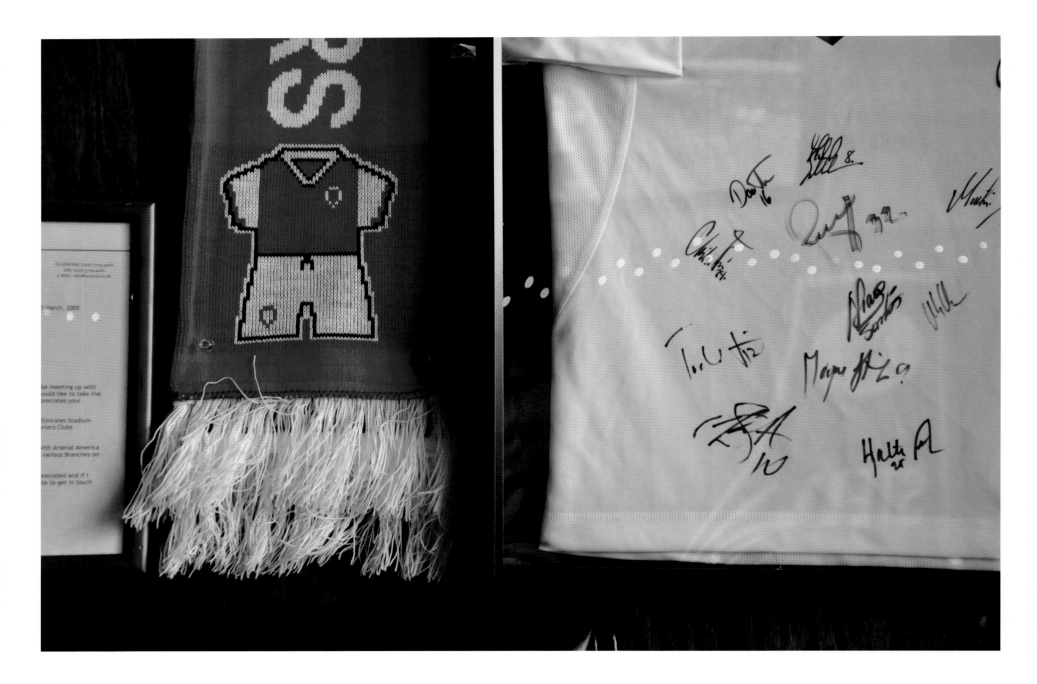

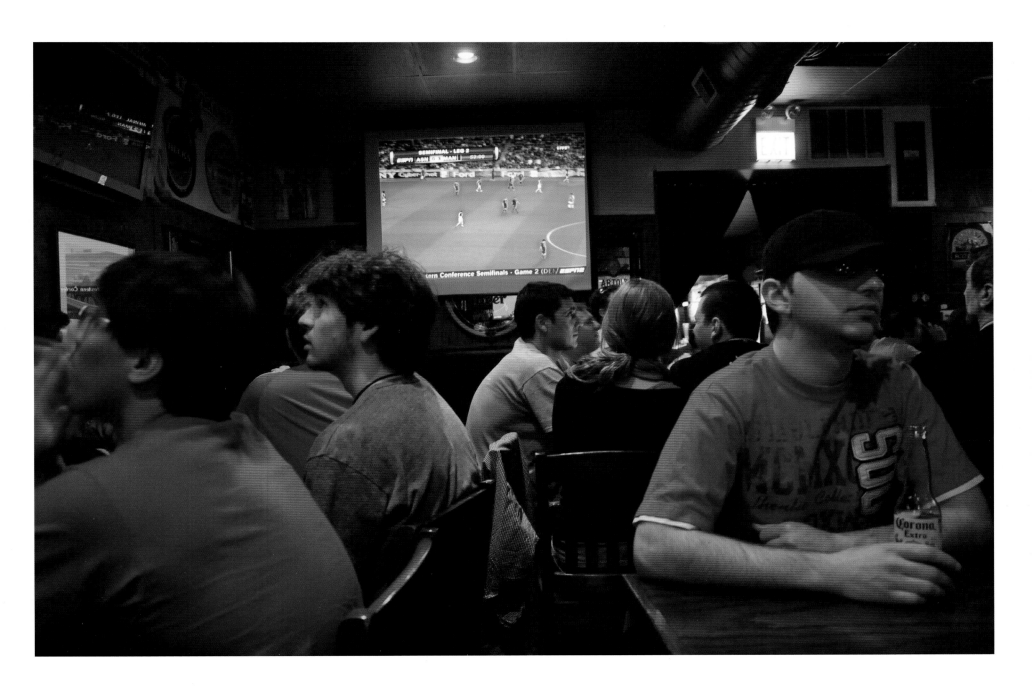

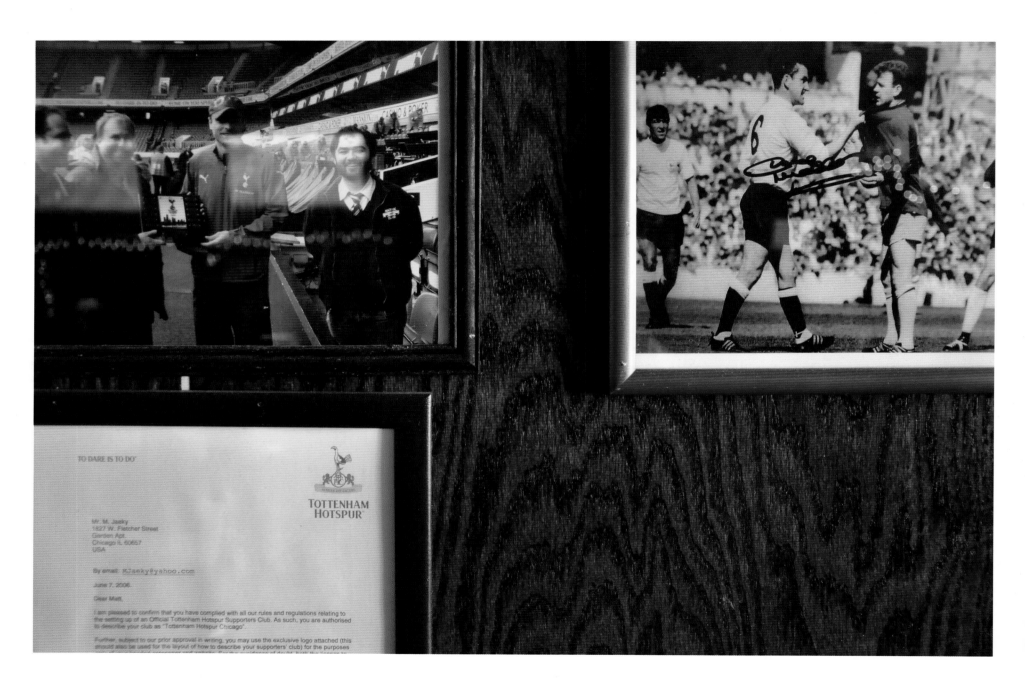

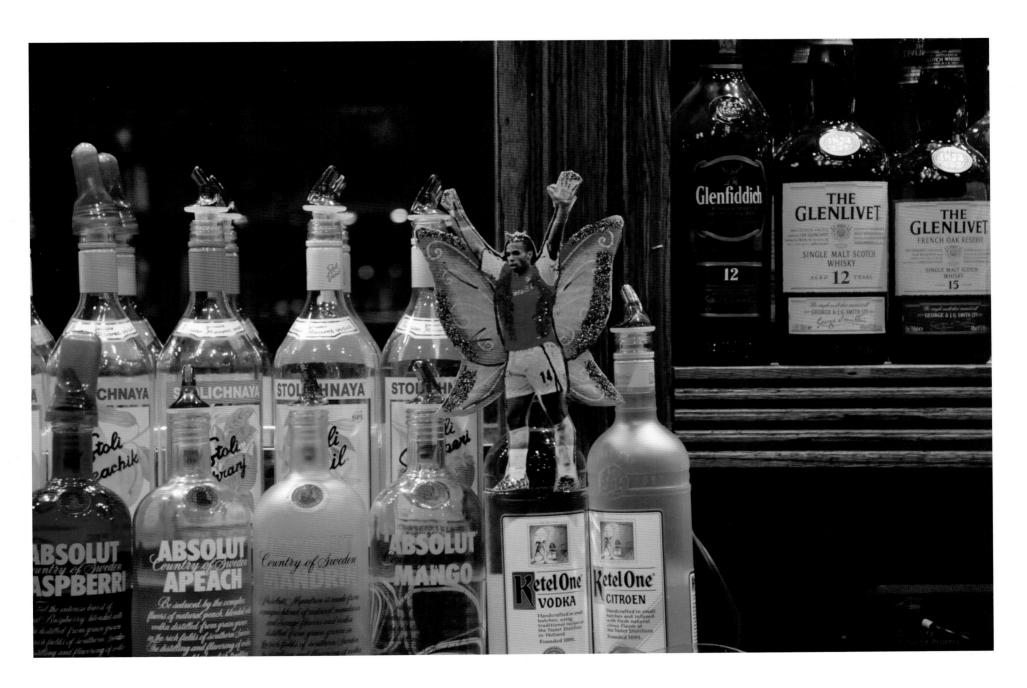

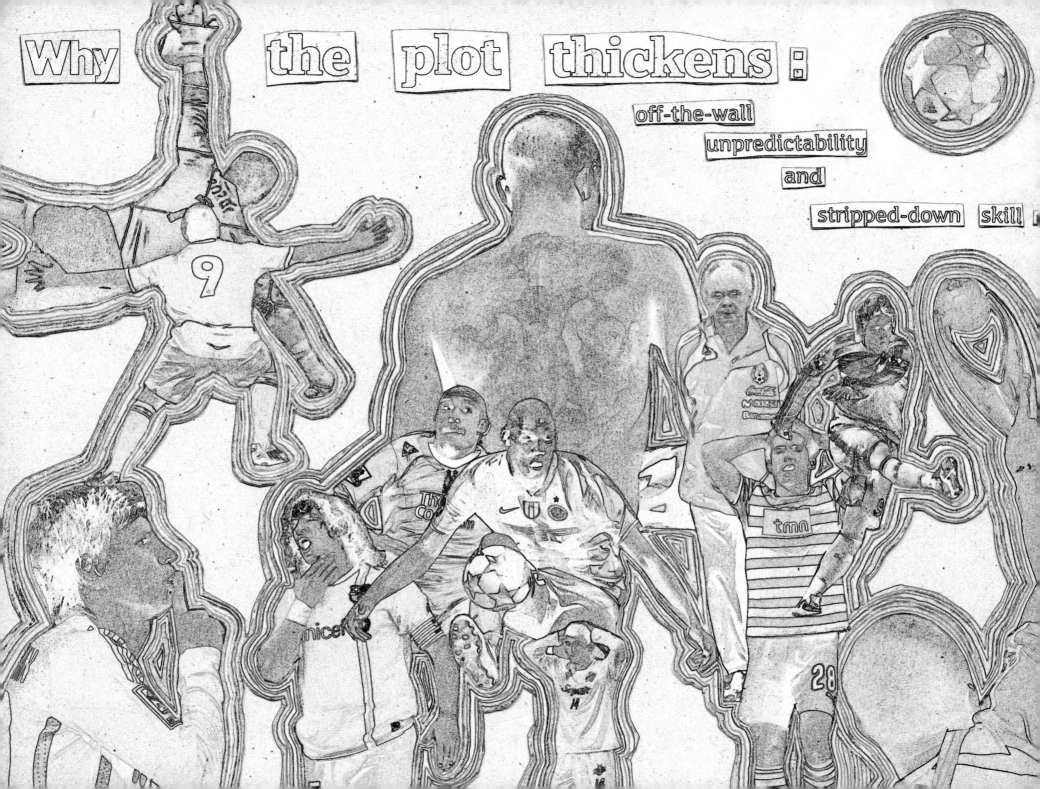

Why the plot thickens :

off-the-wall
unpredictability
and

stripped-down skill

Halftime

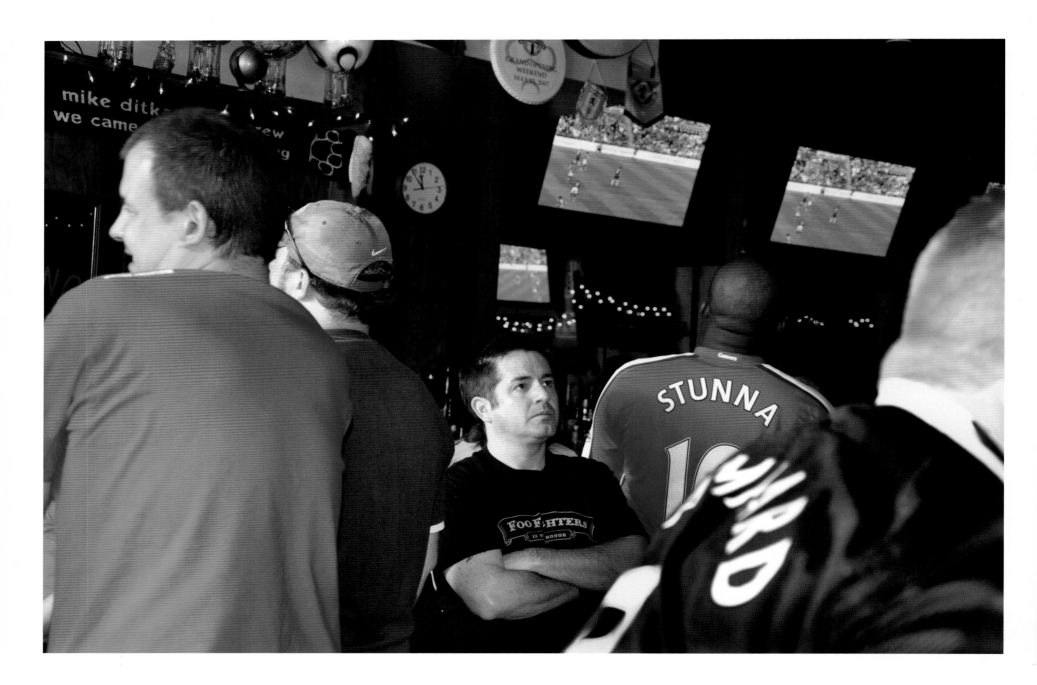

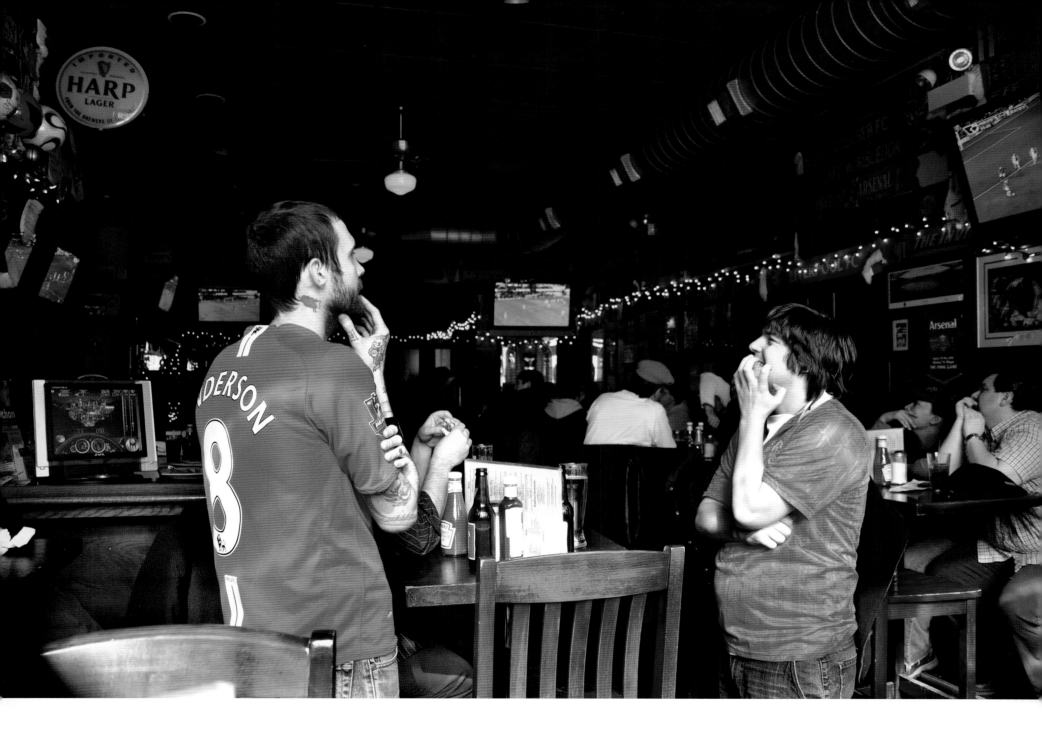

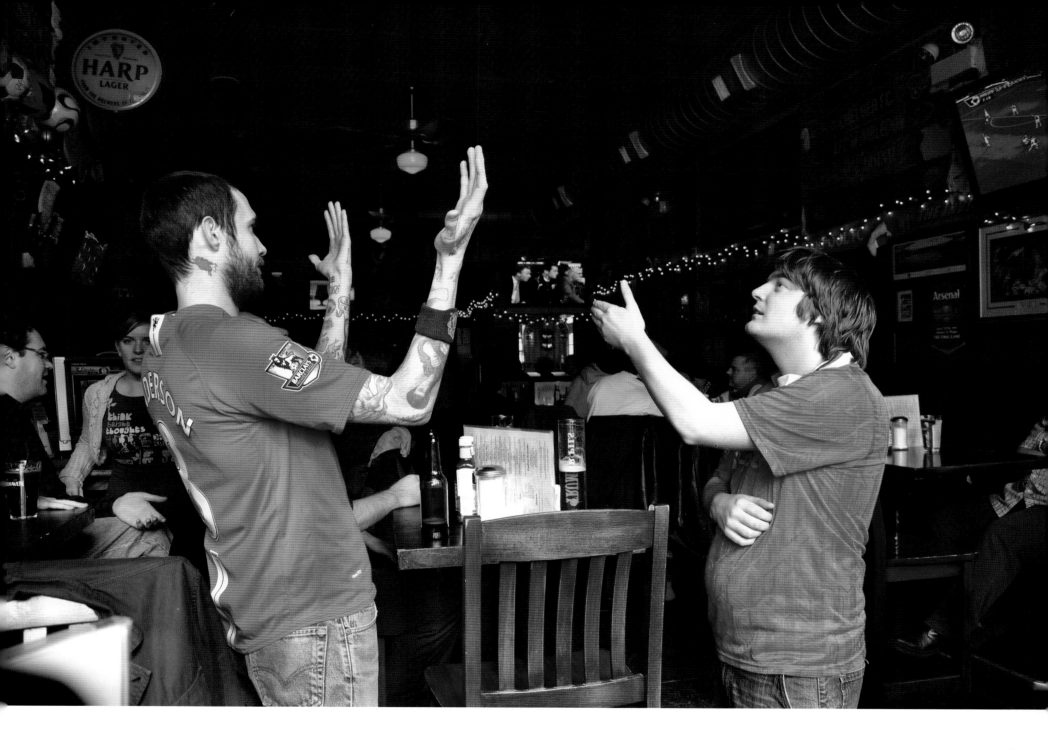

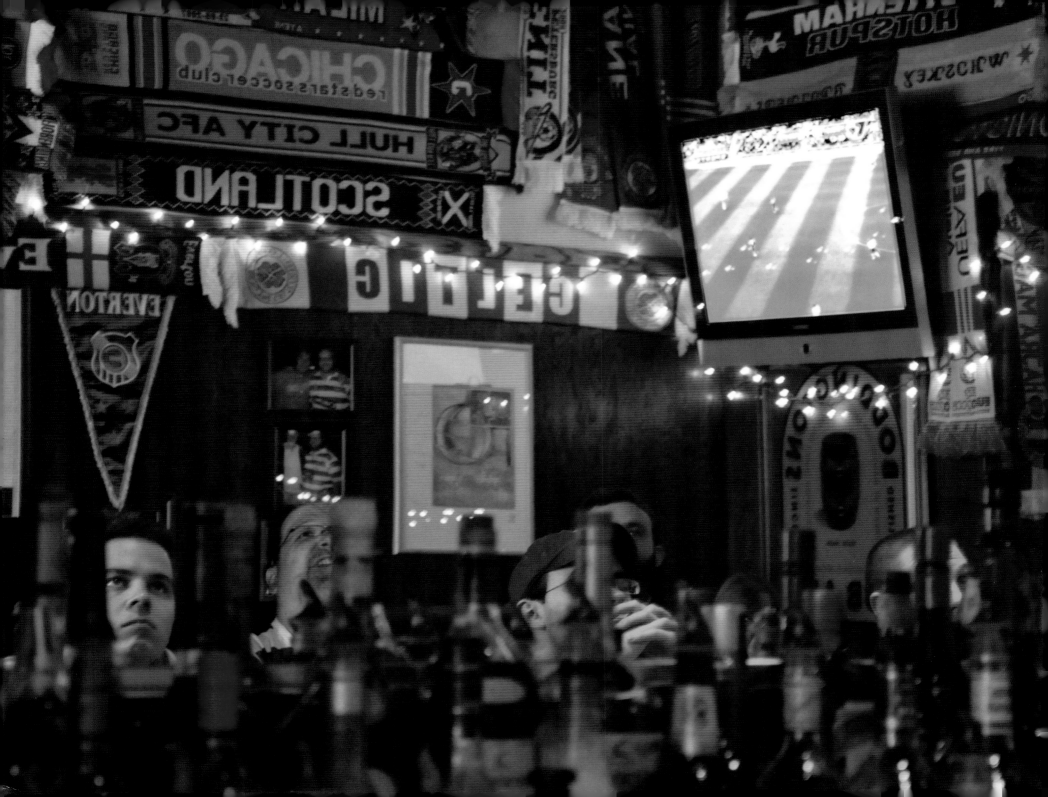

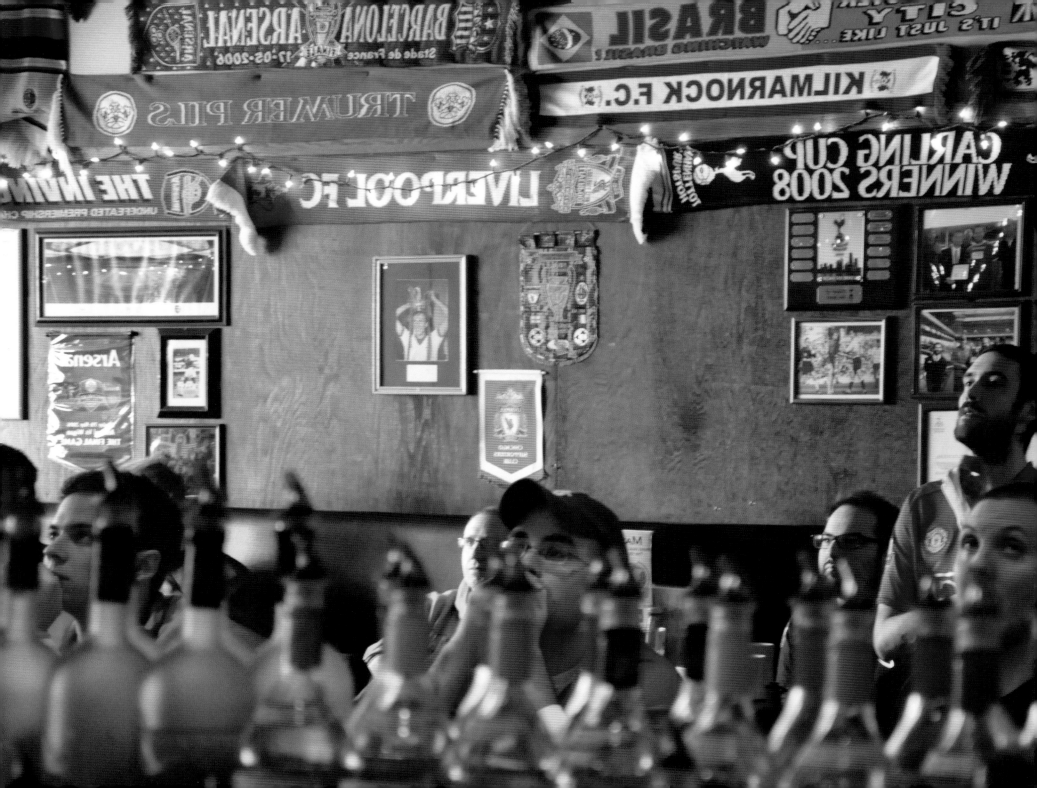

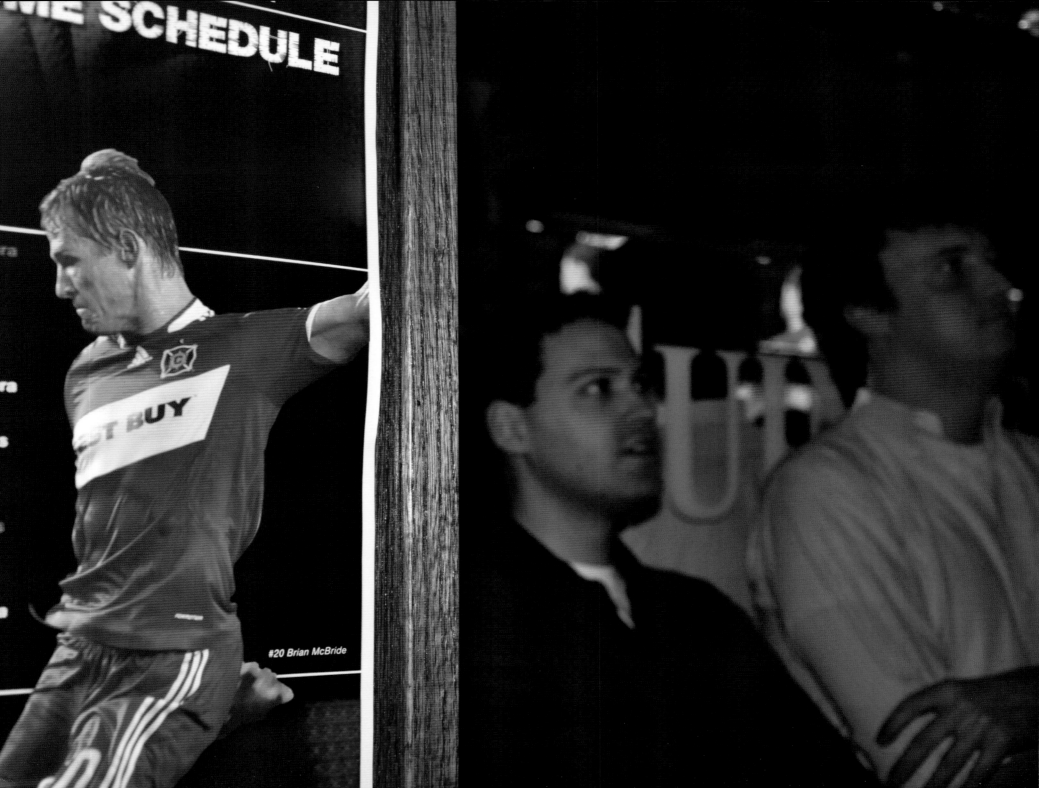

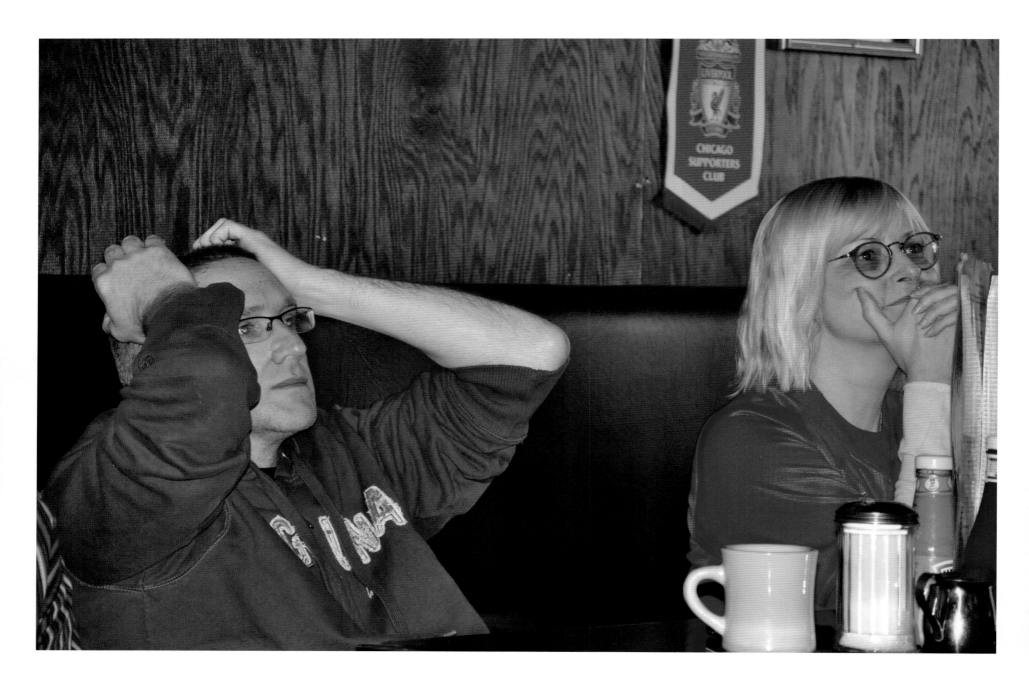

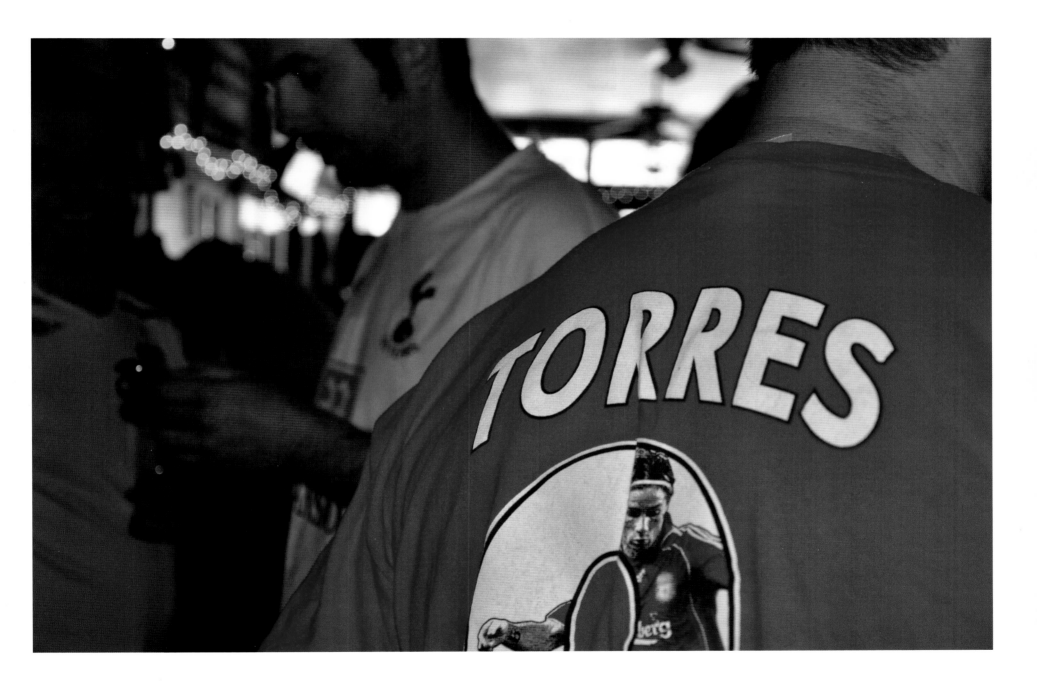

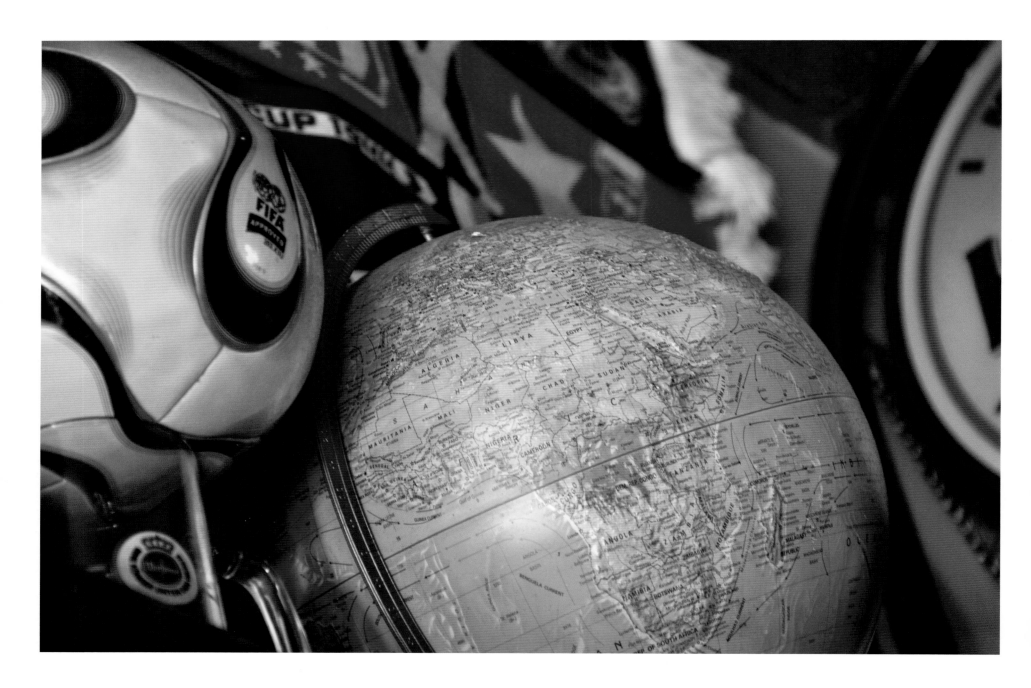

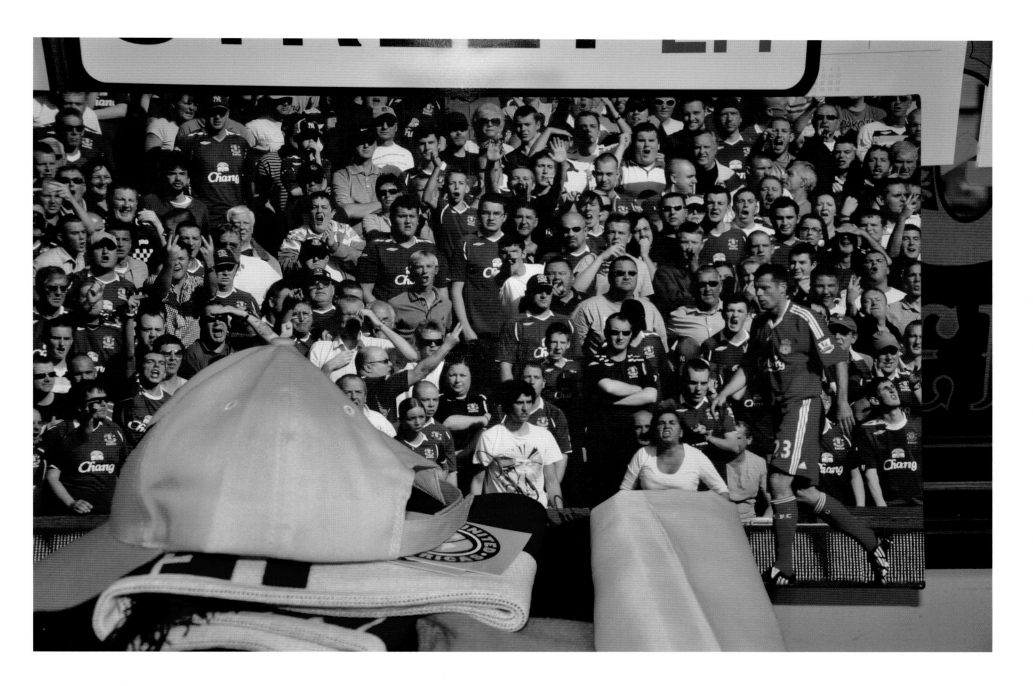

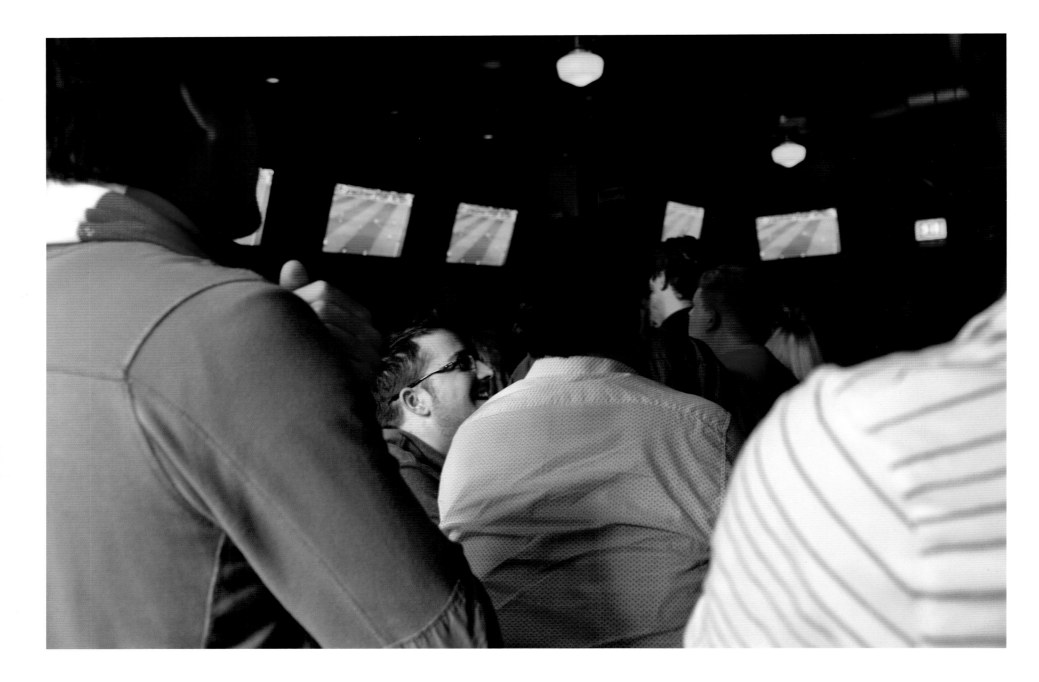

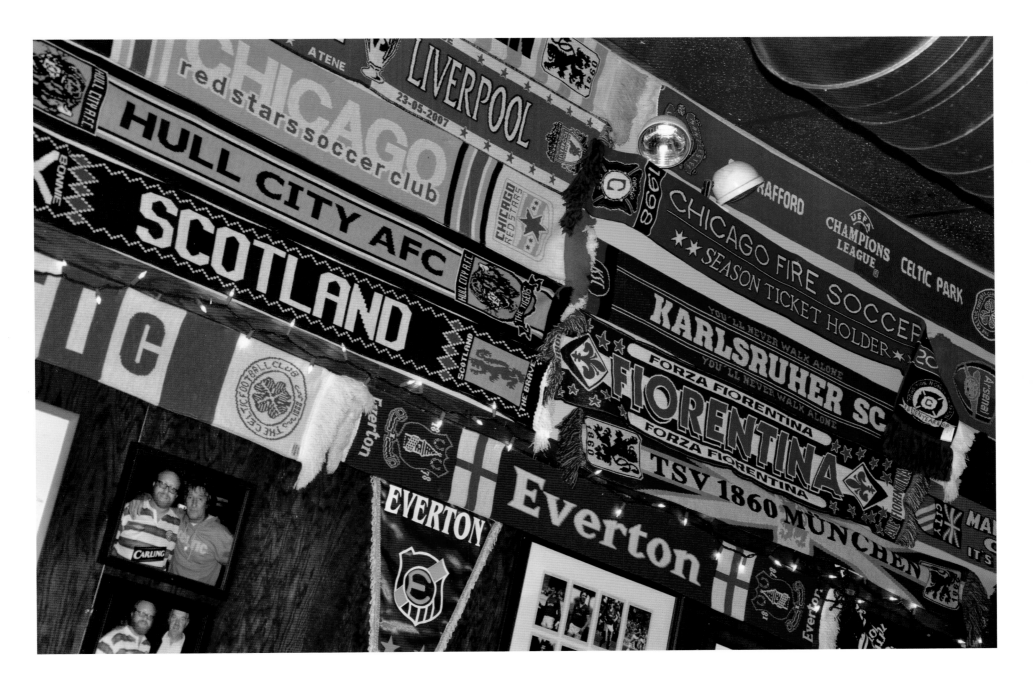

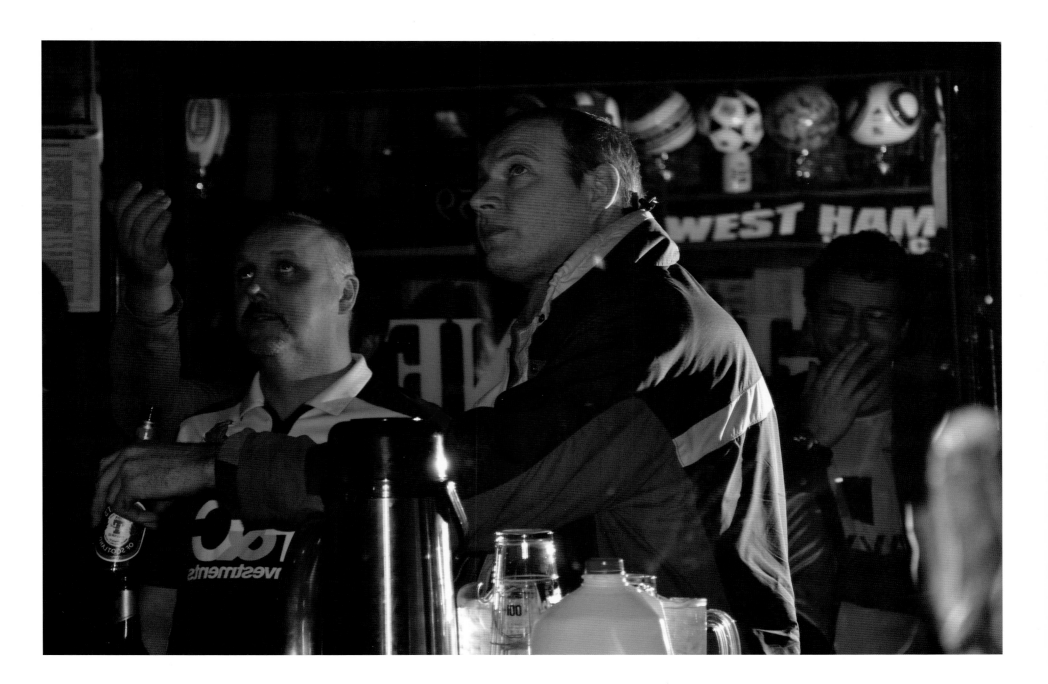

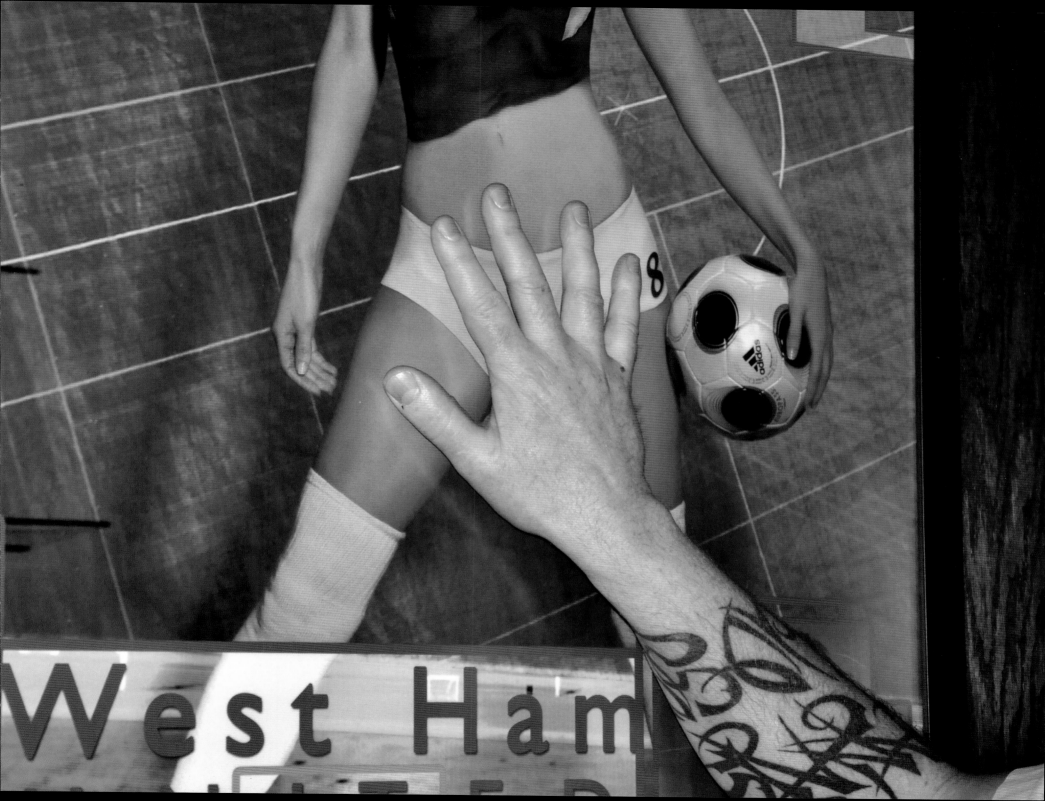

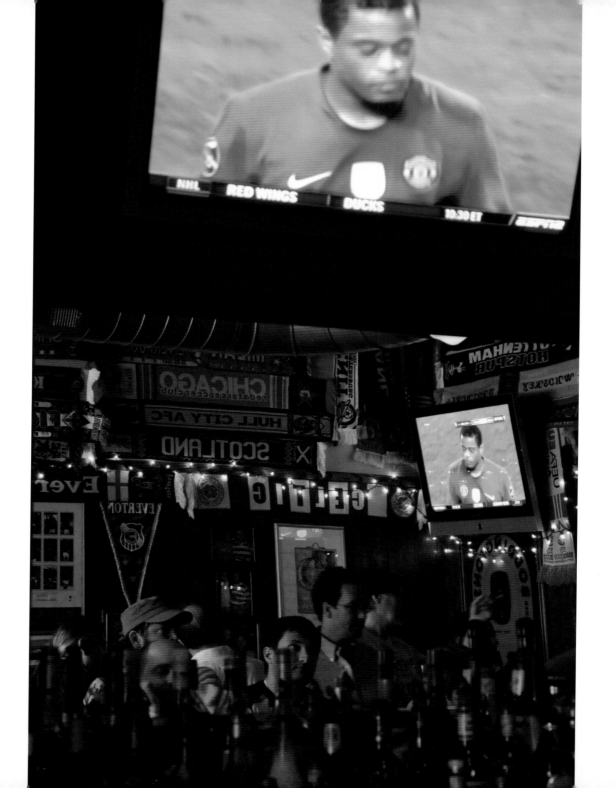

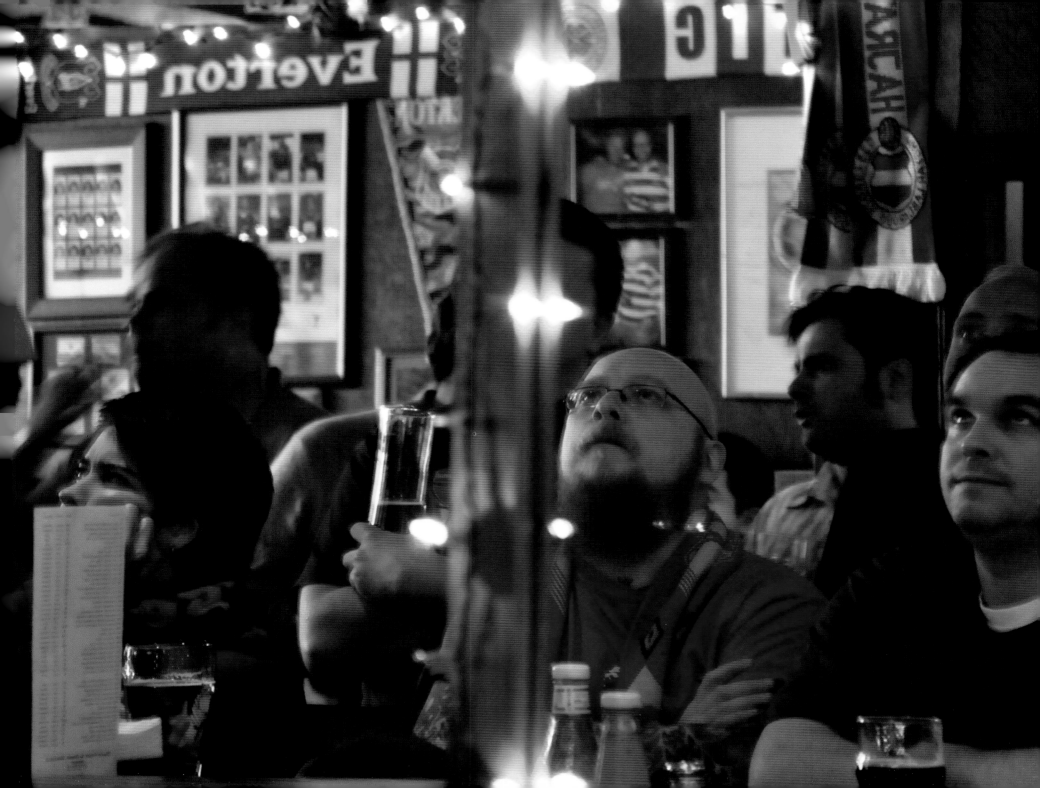

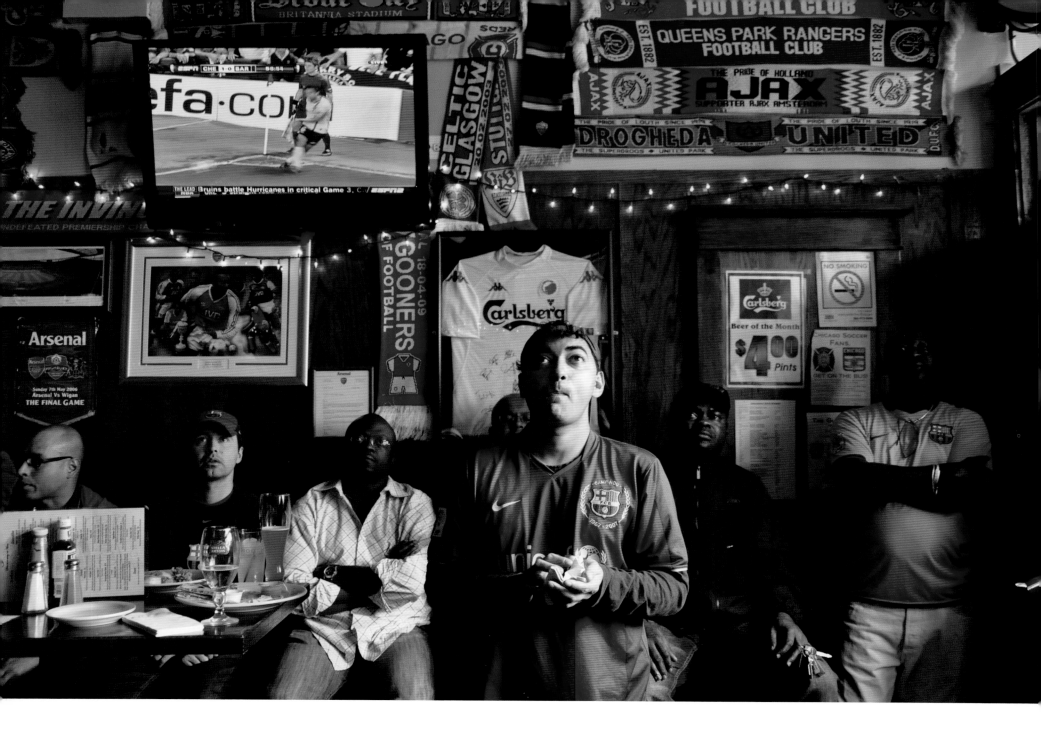

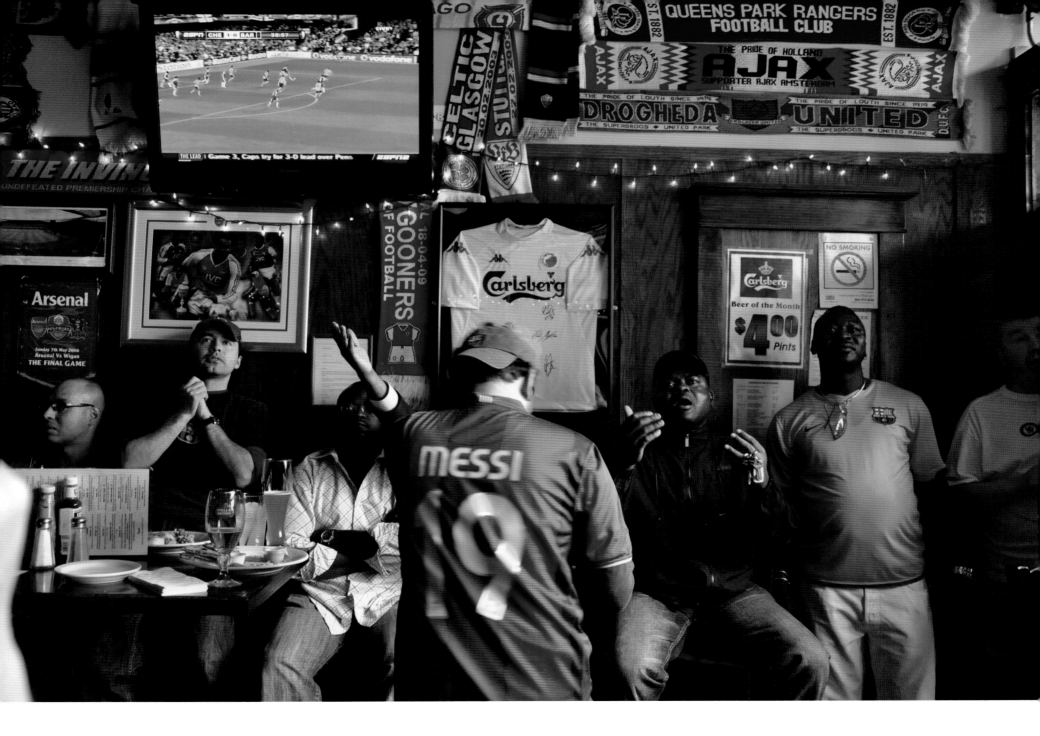

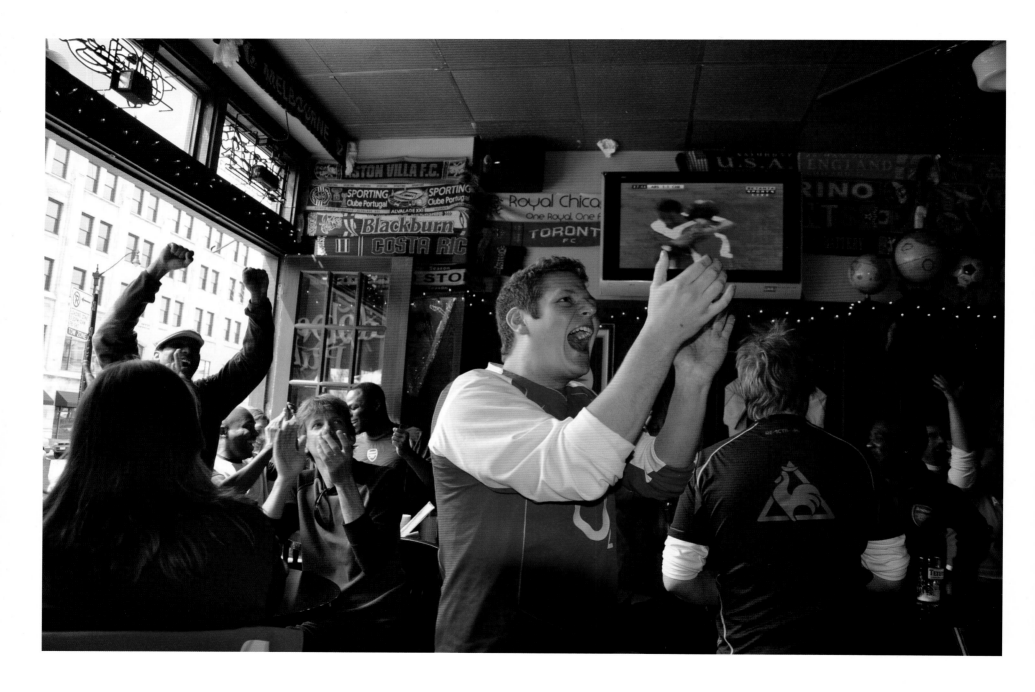

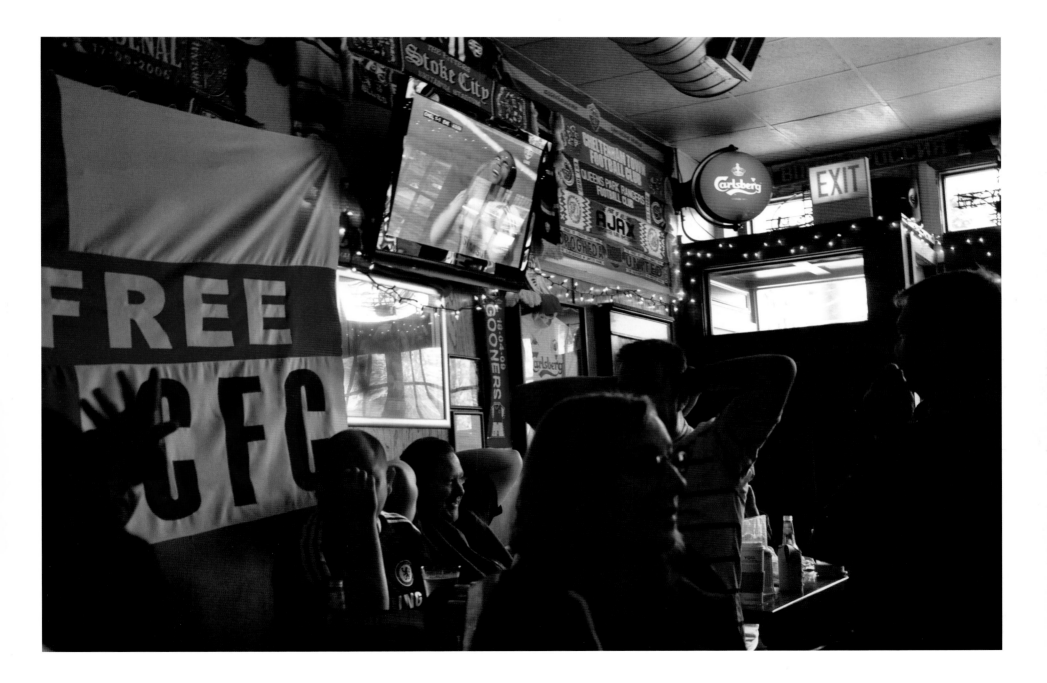

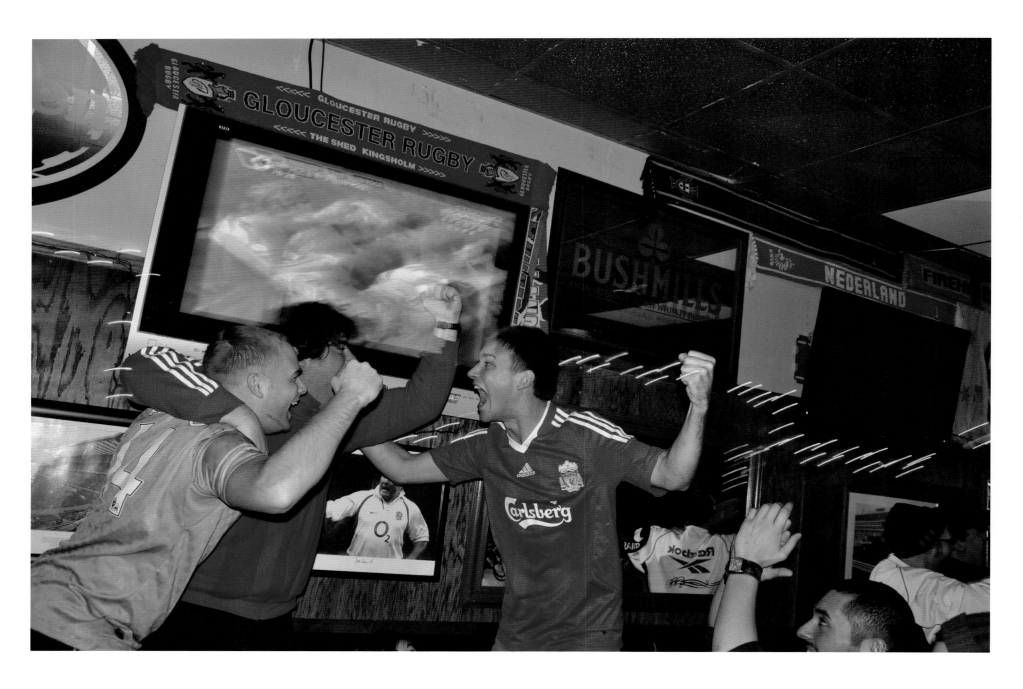

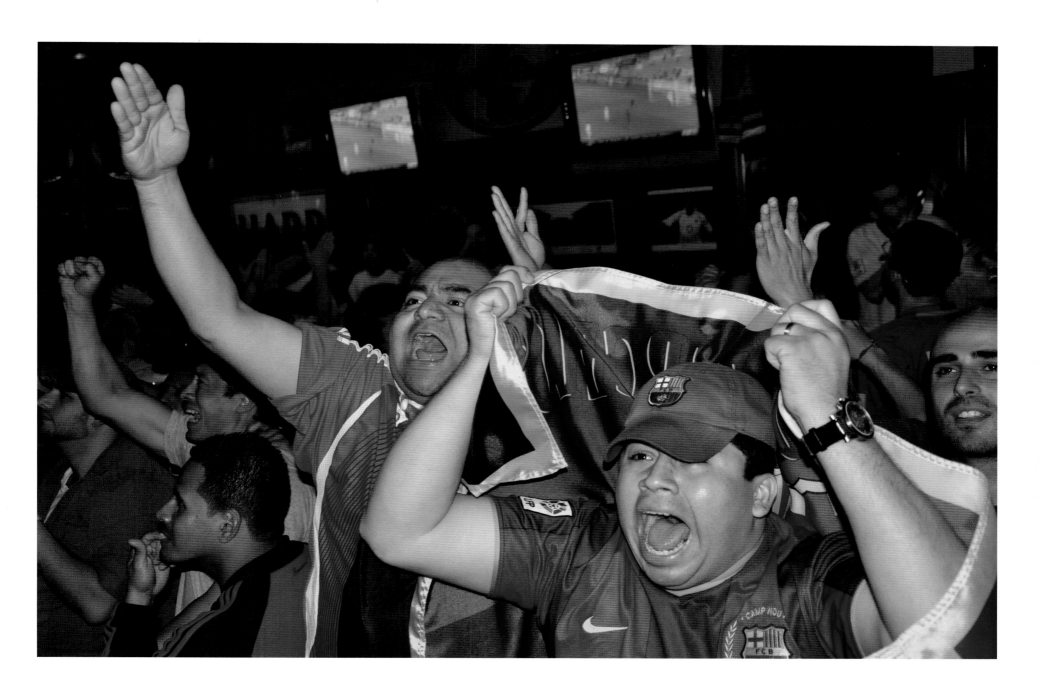

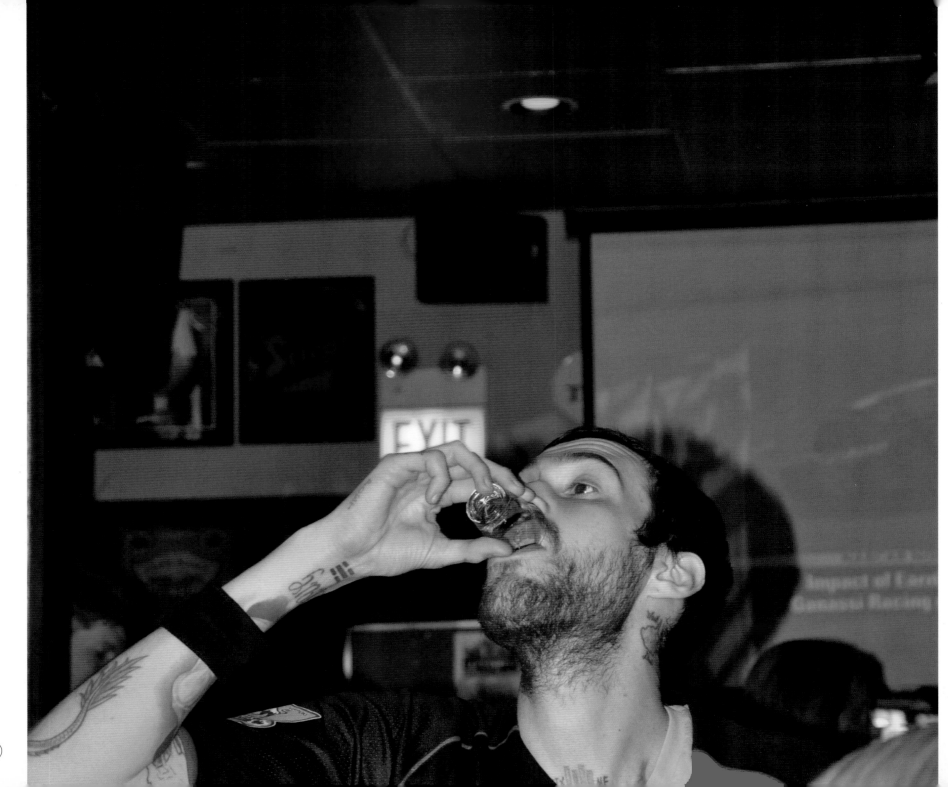

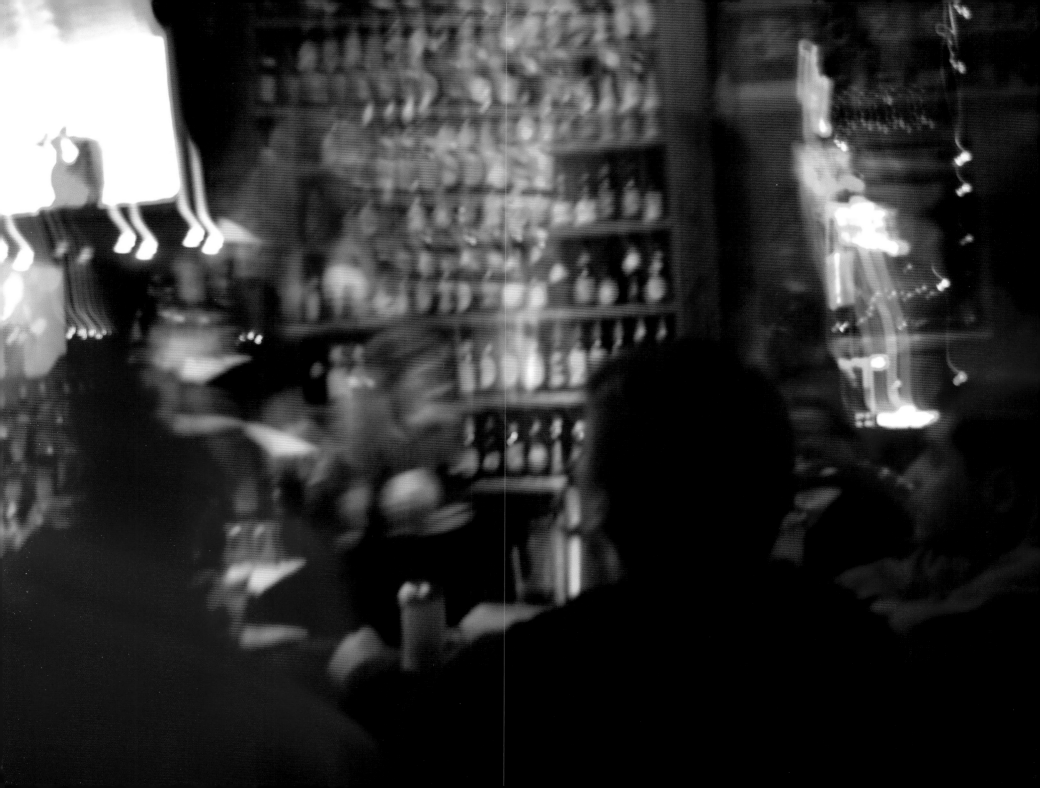

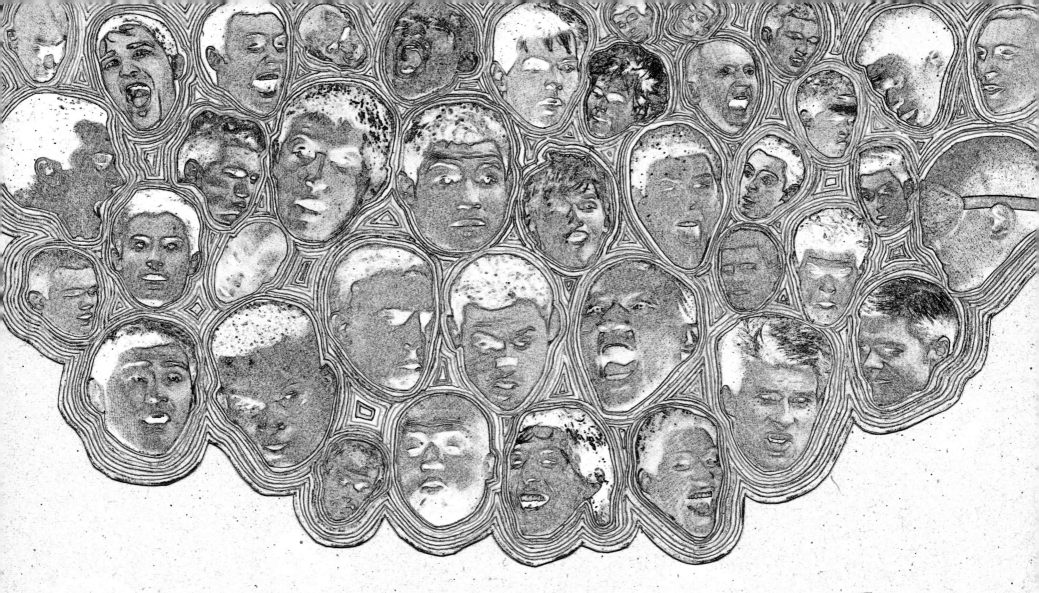

# The Kid done good

**But who will win?**

# Extra Time

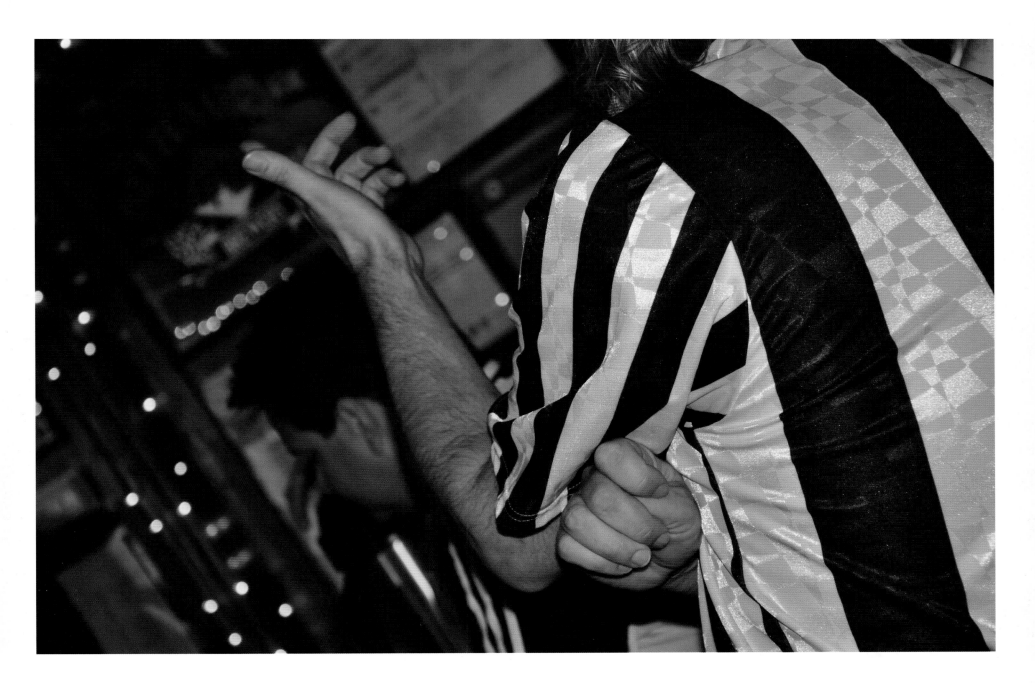

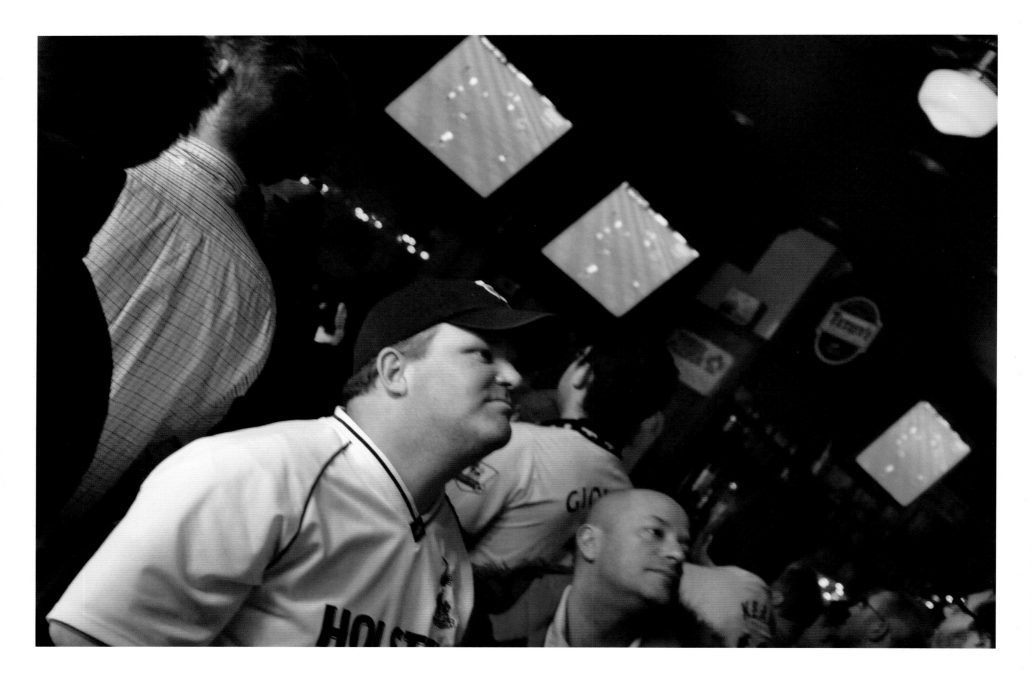

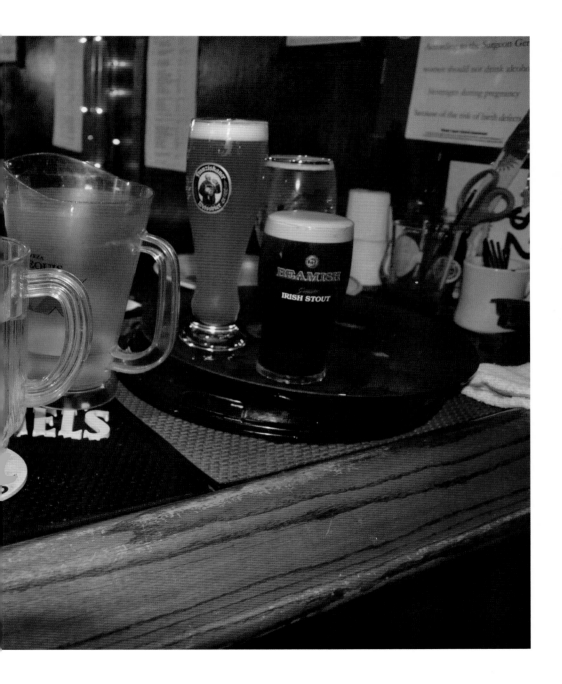

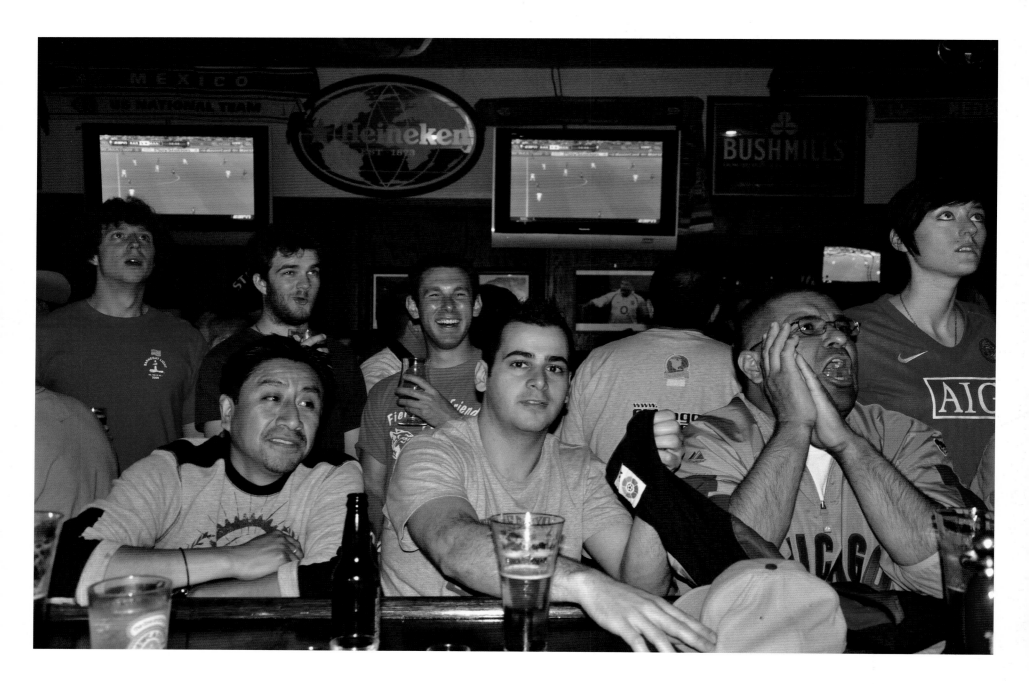

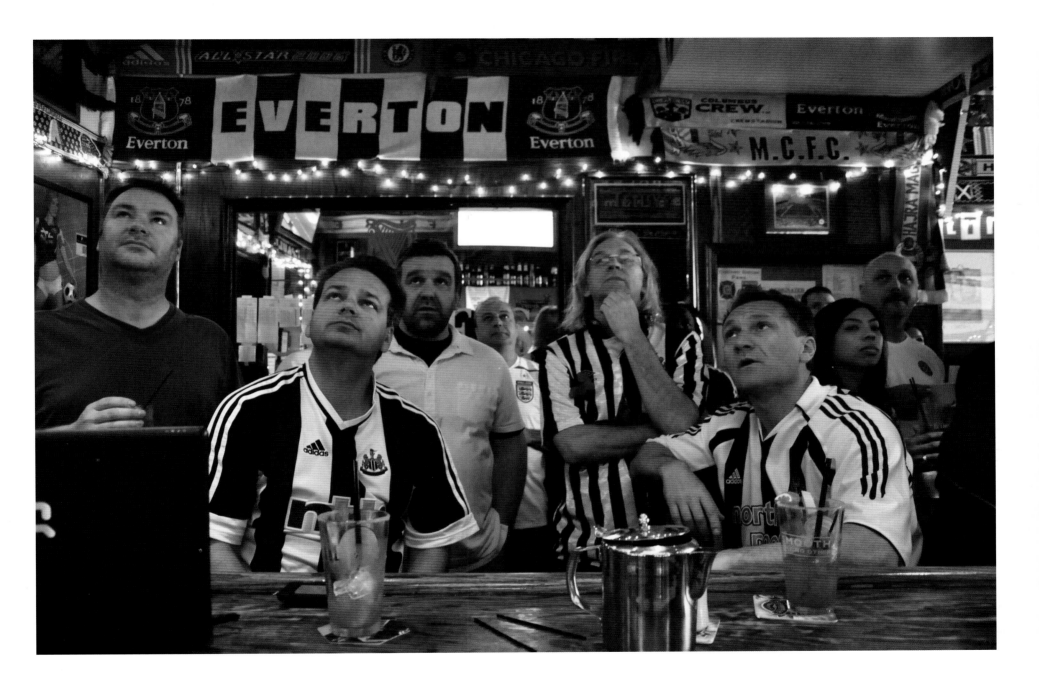

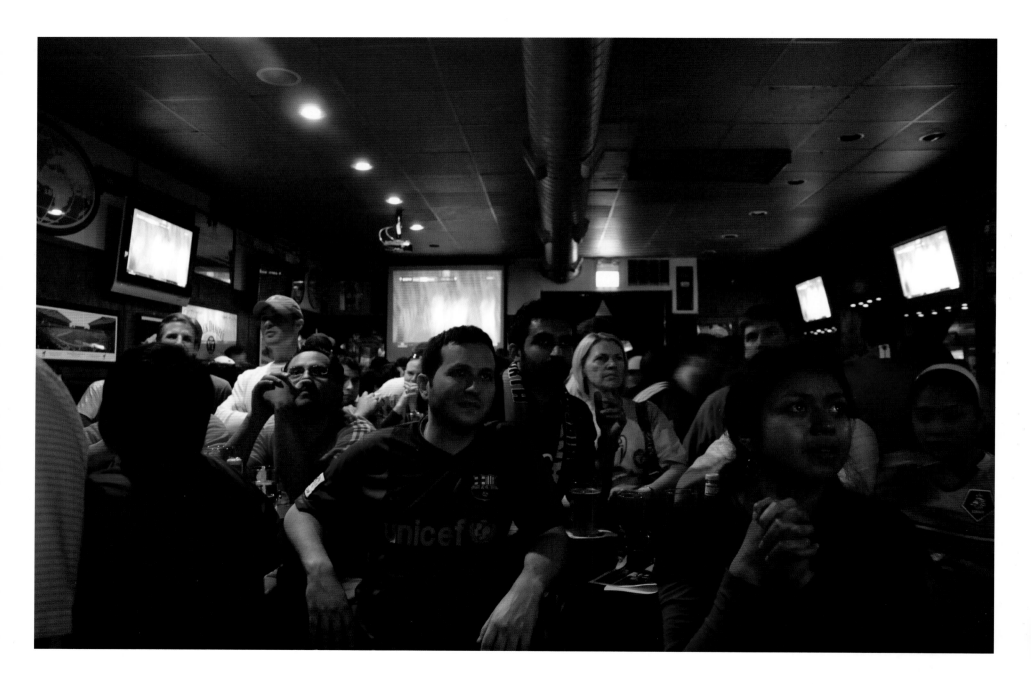

# DESIGNATED
# SMOKING AREA

# OUTSIDE

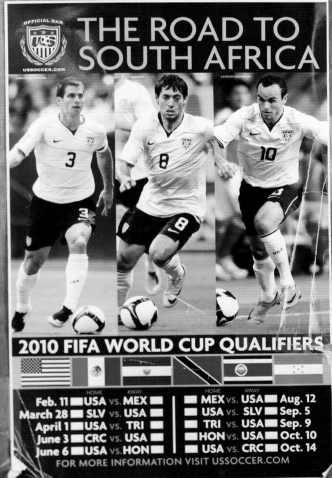

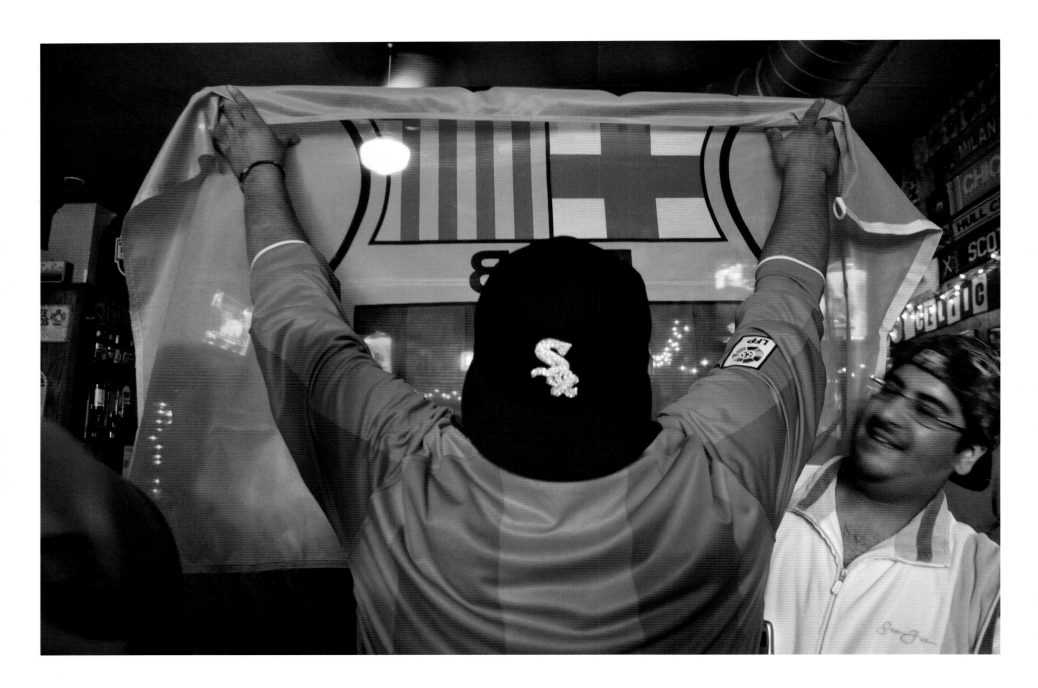

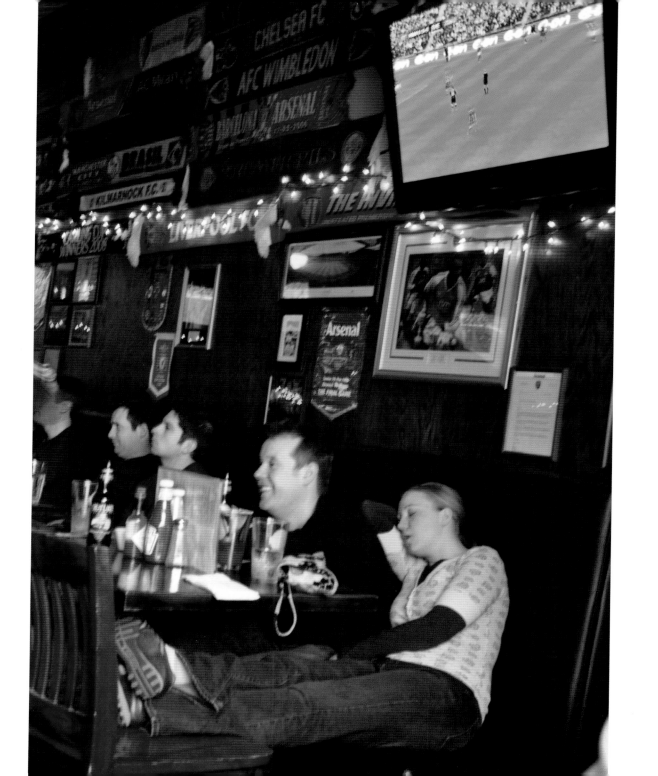

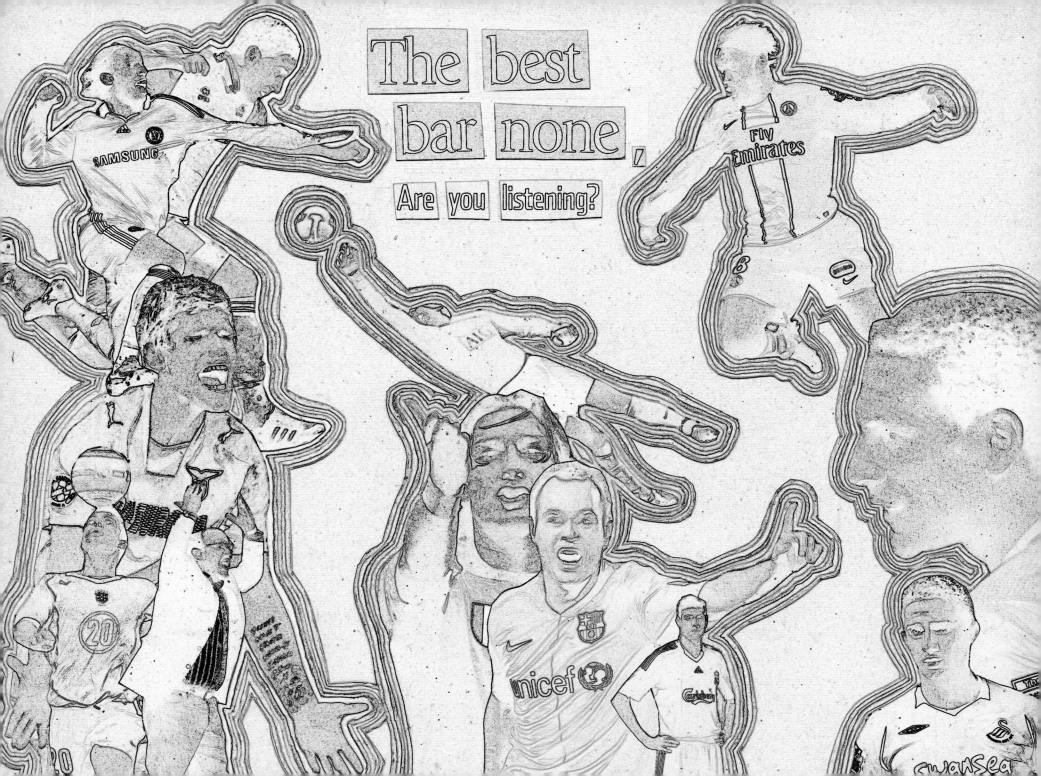

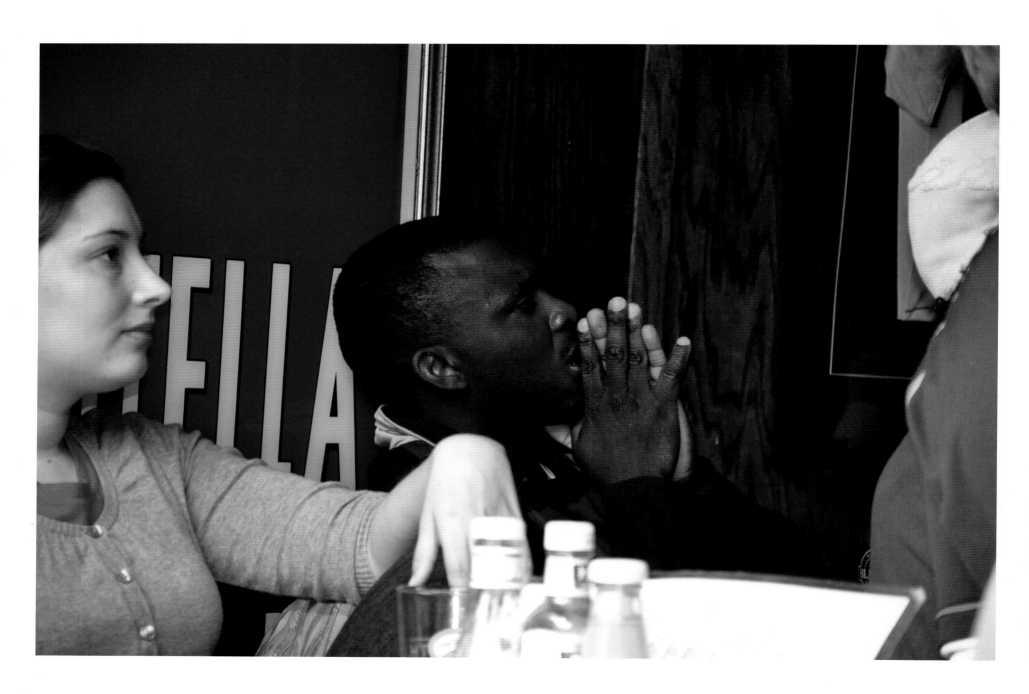

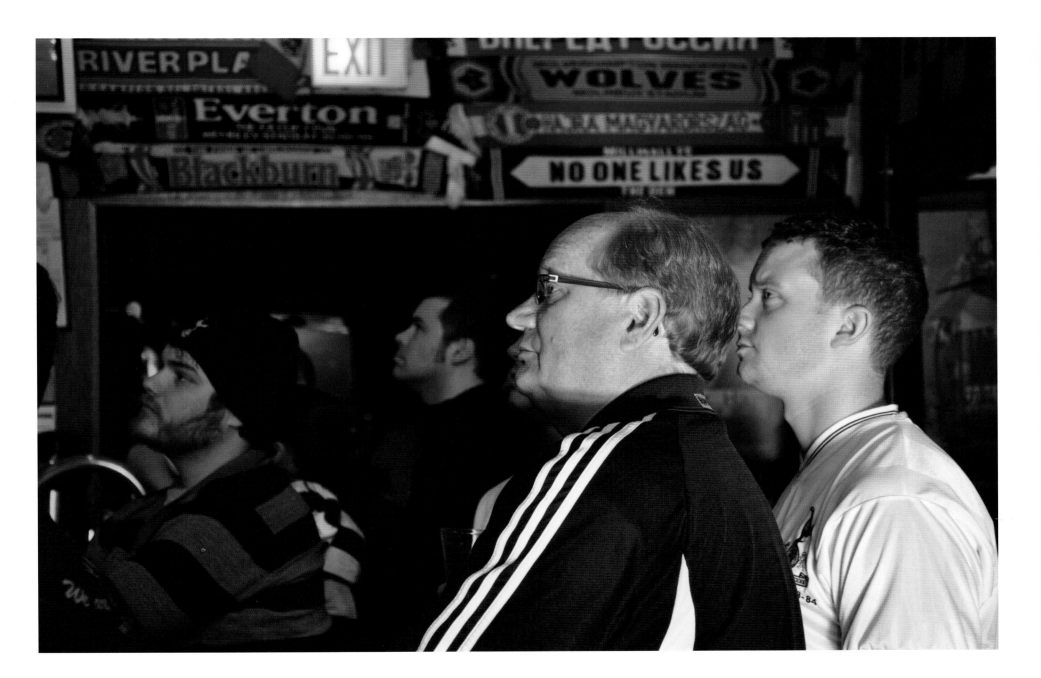

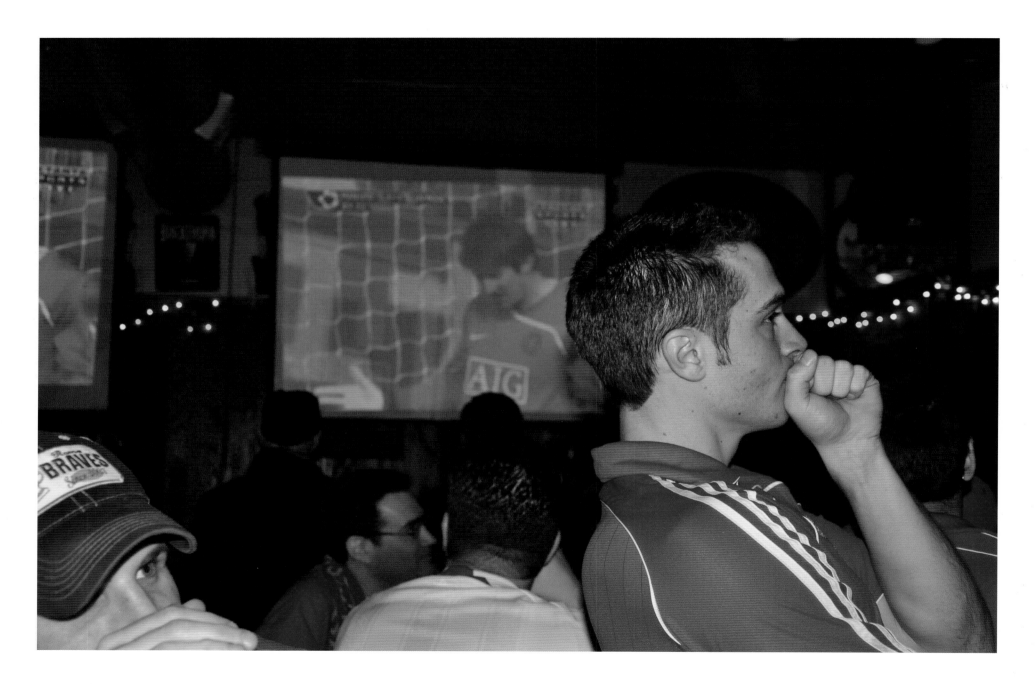

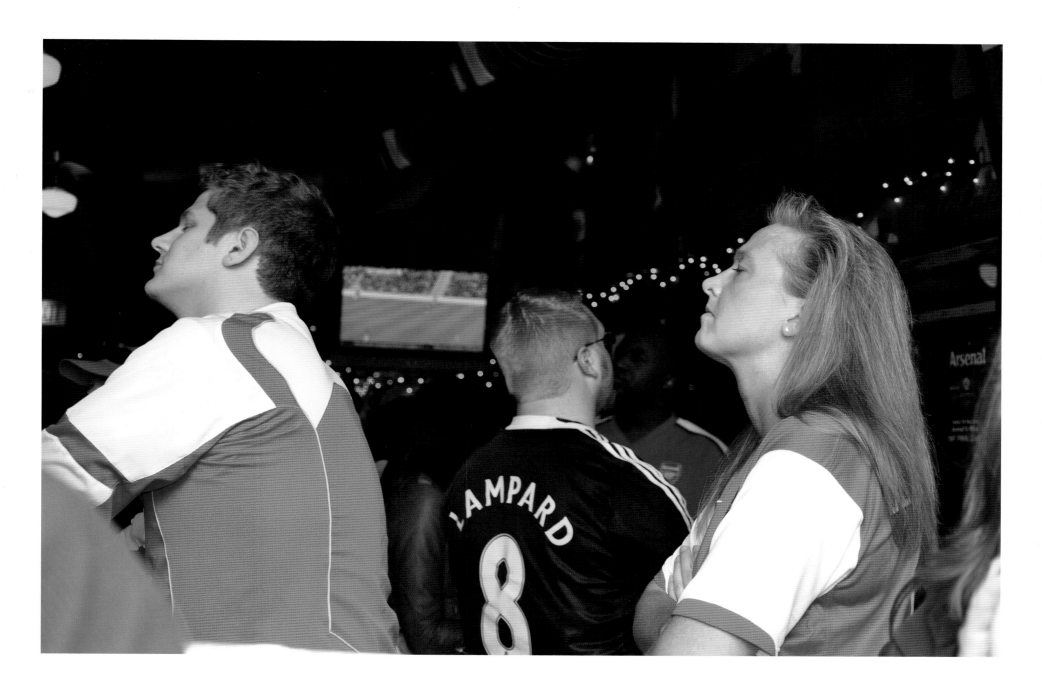

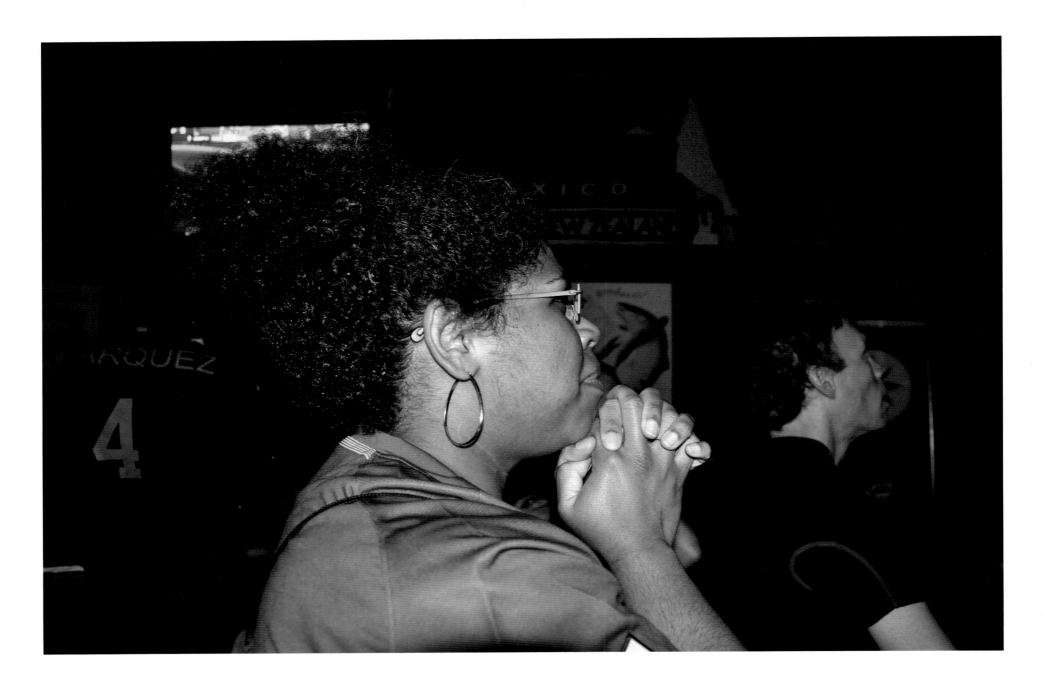

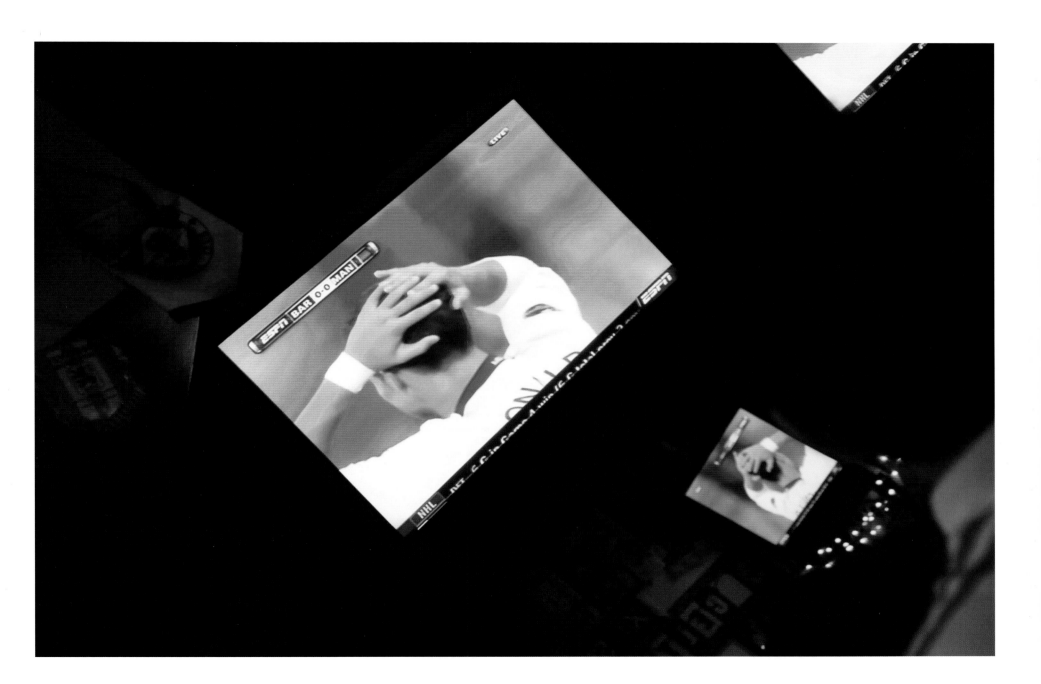

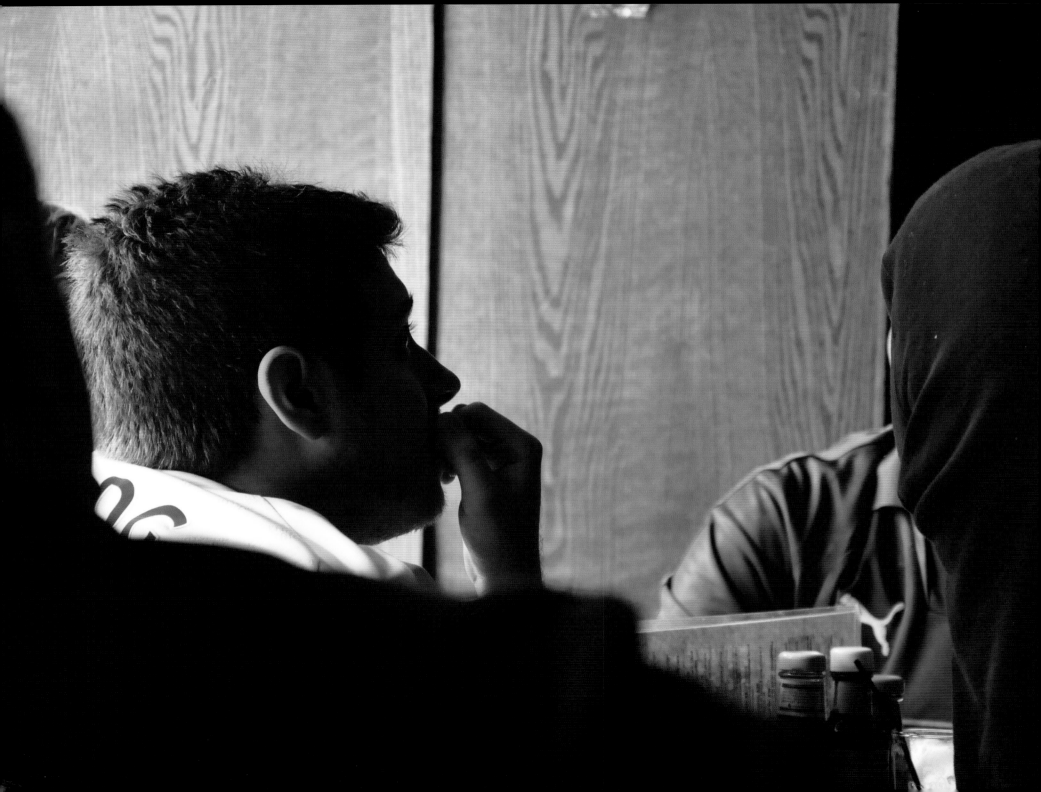

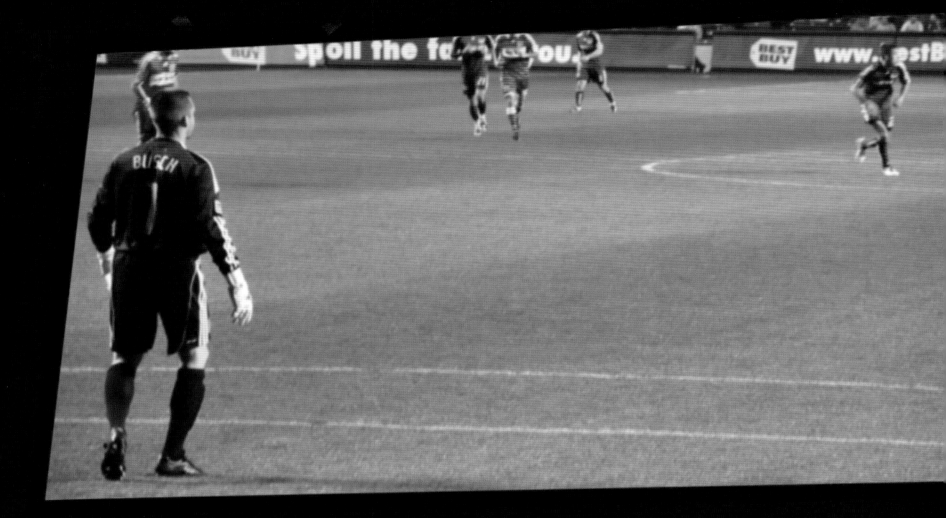

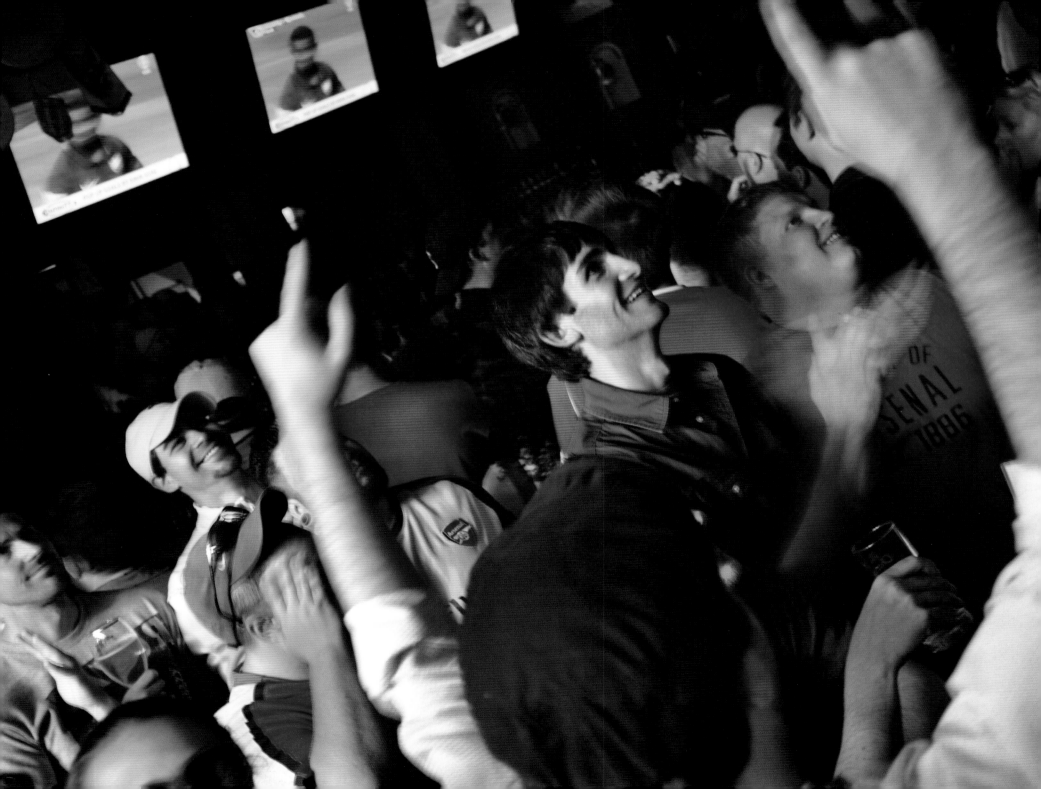

THIS DOES NOT INCLUDE A MATCH TIC

To pre book a space on the bus. RSVP jamie@theglobepub.com A
number will be taken to reserve spaces. The card will
in the event of no shows.
Cash will be taken on the day of the game.

## ports Schedule

| | |
|---|---|
| Barcelona | 1.45, 7pm |
| | 6.30pm |
| | |
| | 9.30pm |
| | |
| Swans | 2, 7pm |
| | 11pm |
| | |
| | 9am |
| | 12, 7.45pm |
| Werder Bremen | 1.30pm |
| | 2pm |
| Lions | 6pm |
| | 6pm |
| | 6.30pm |
| | 7.30pm |
| | 7.30pm |
| | 9.30pm |
| | 9.30pm |
| | 9.30pm |
| | 1.30am |
| | |
| | 8am |
| | 10am |
| | 12pm |
| | 2pm |
| | 2.30pm |
| | 5pm |
| | |
| Lions | 12, 6.45pm |
| les | 5pm |
| | 9pm |
| | |
| ns | 7am |
| | 8am |
| | 10am |
| | 10am    Setanta $20* |
| | 11am |

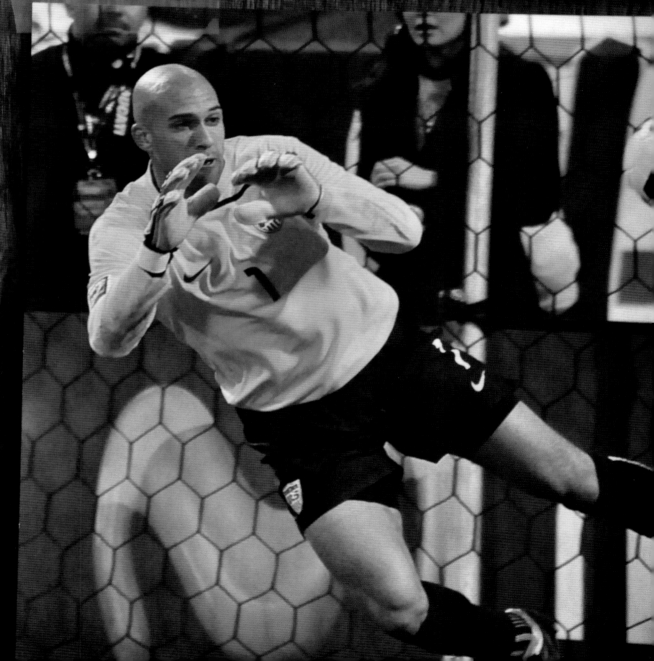

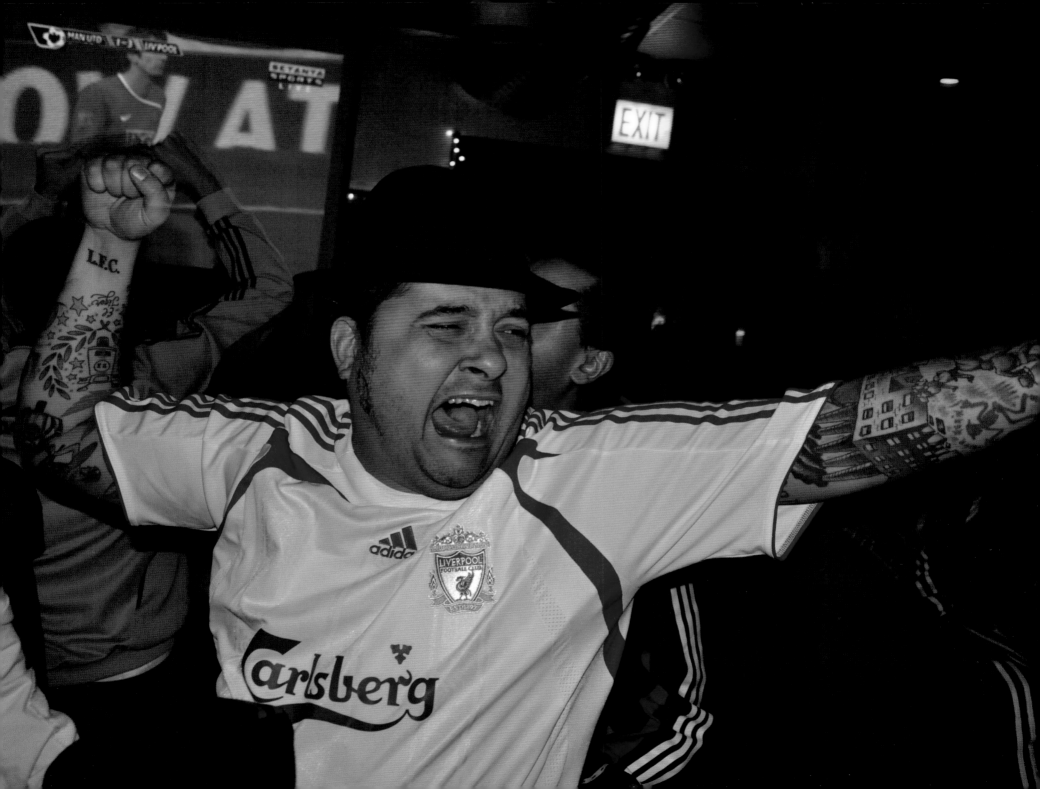

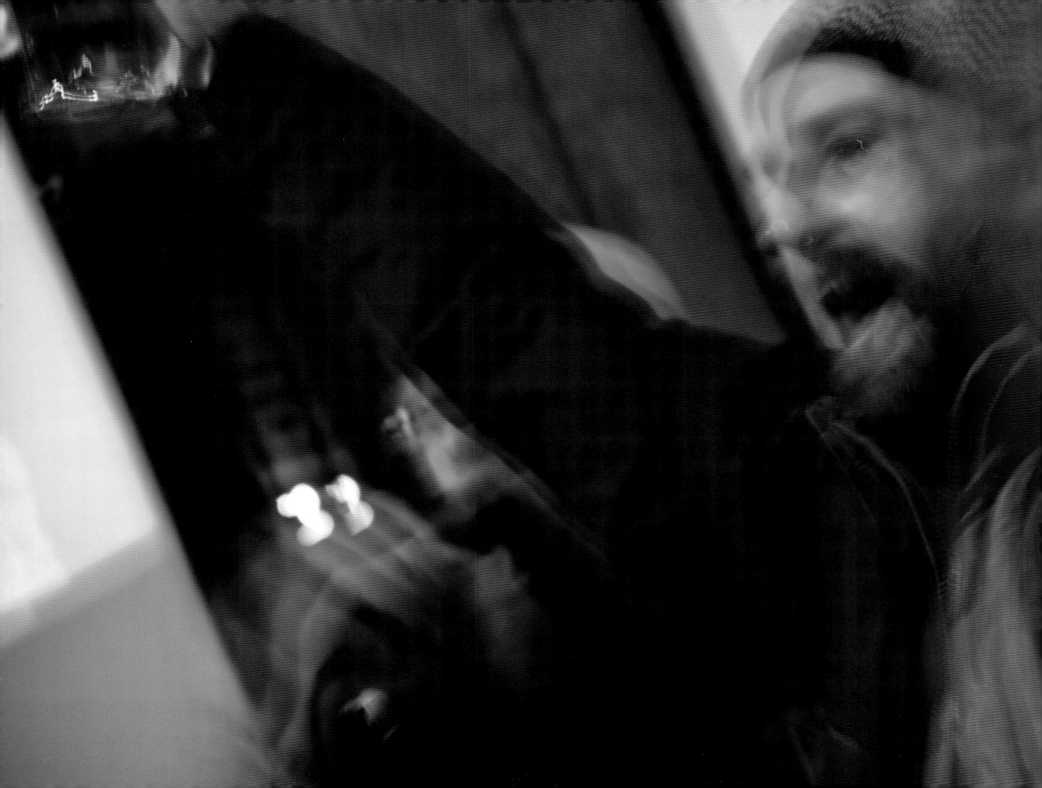

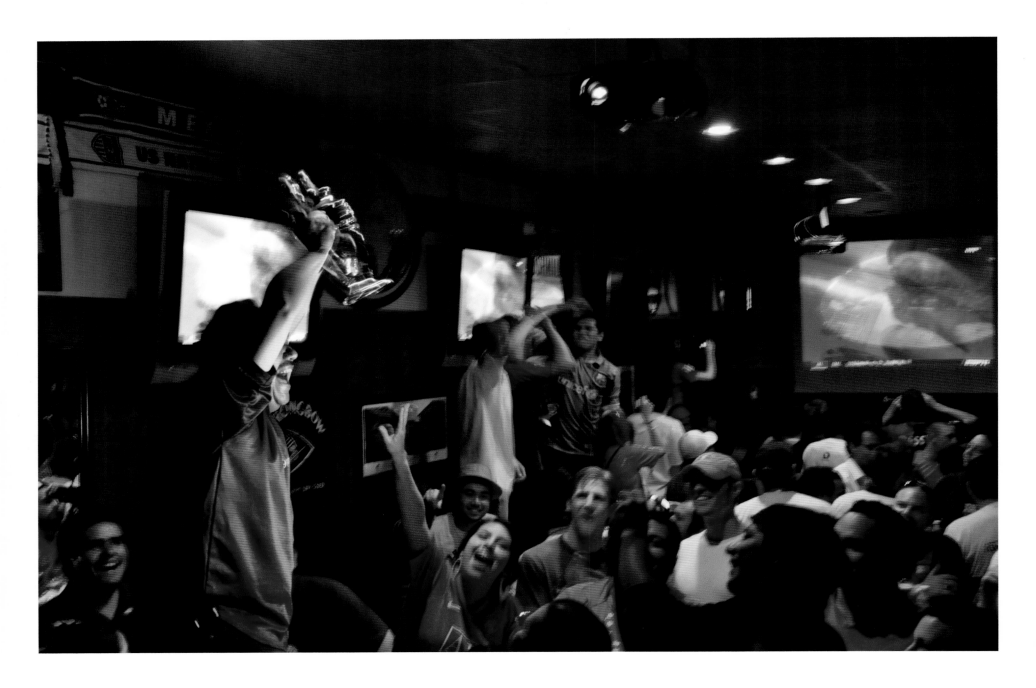

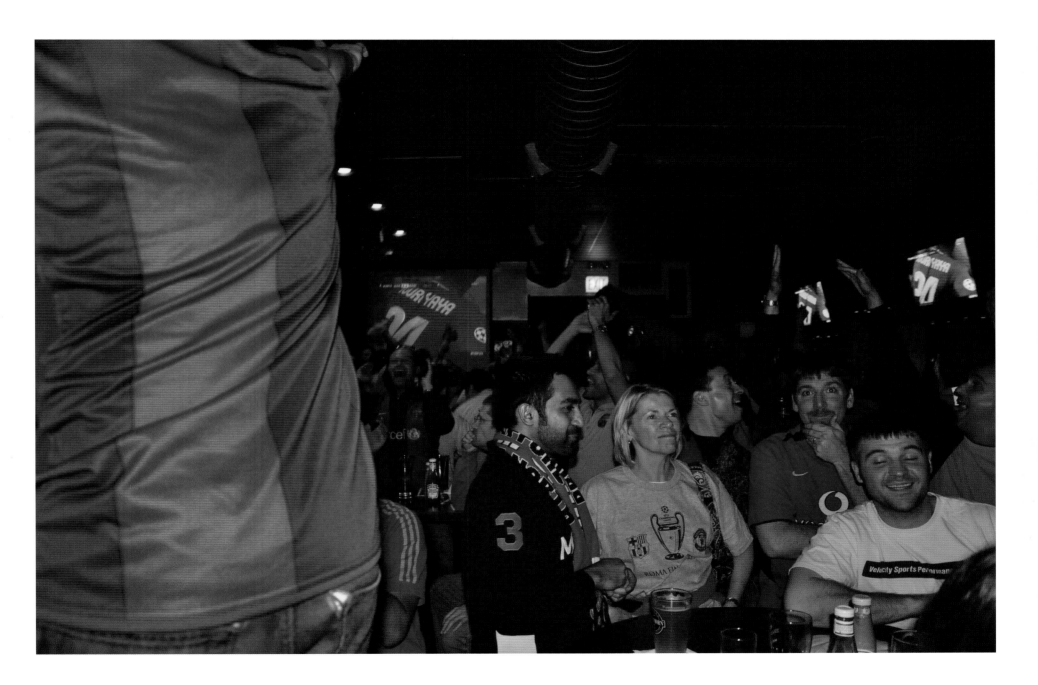

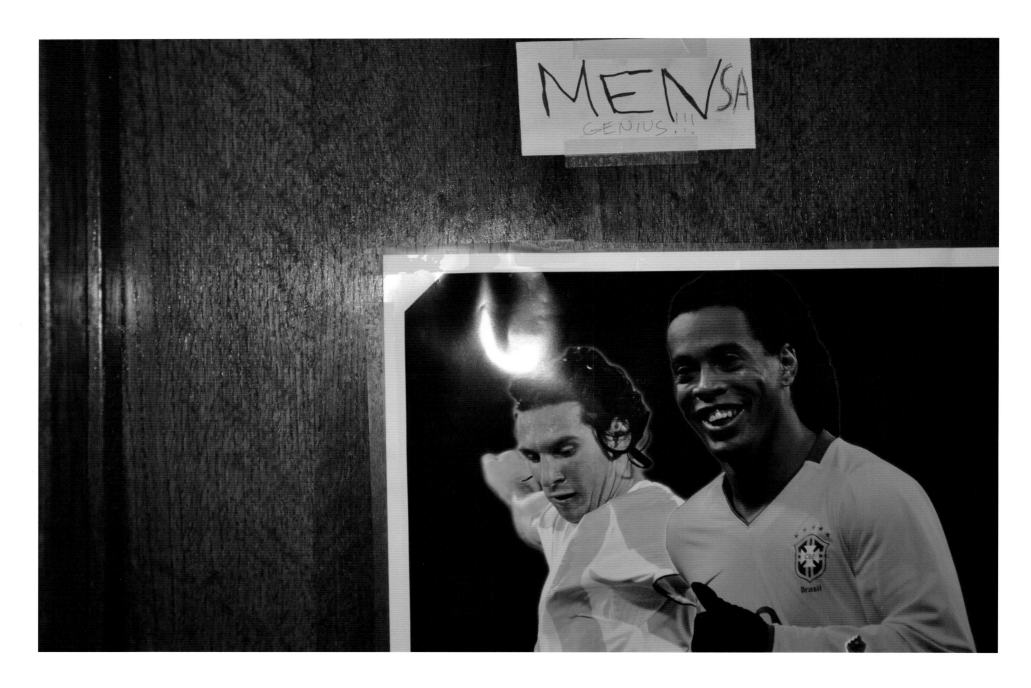

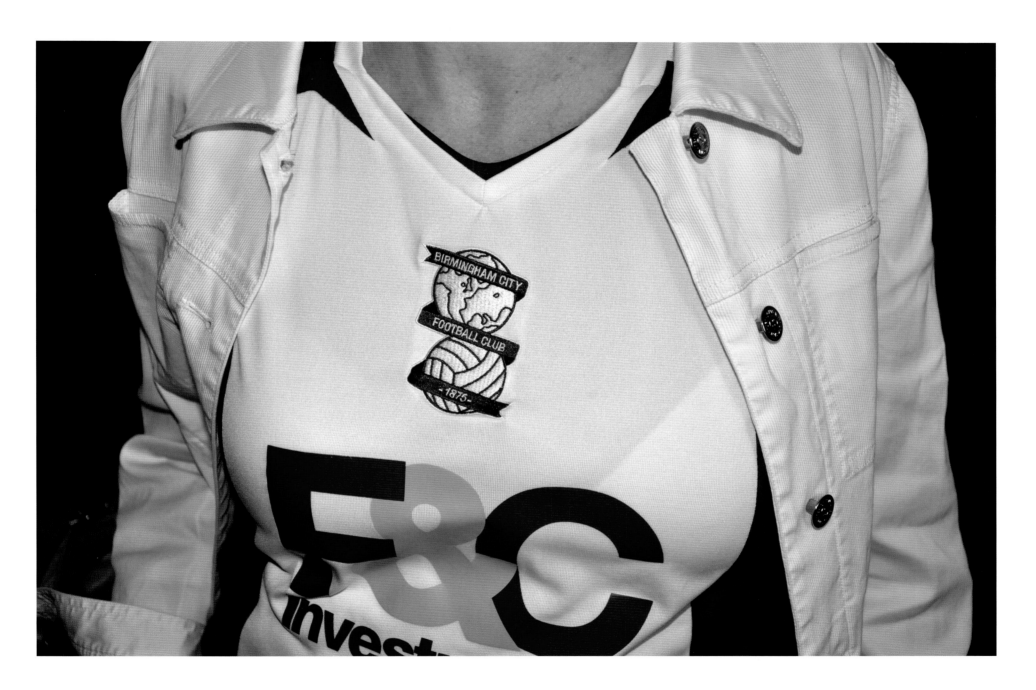

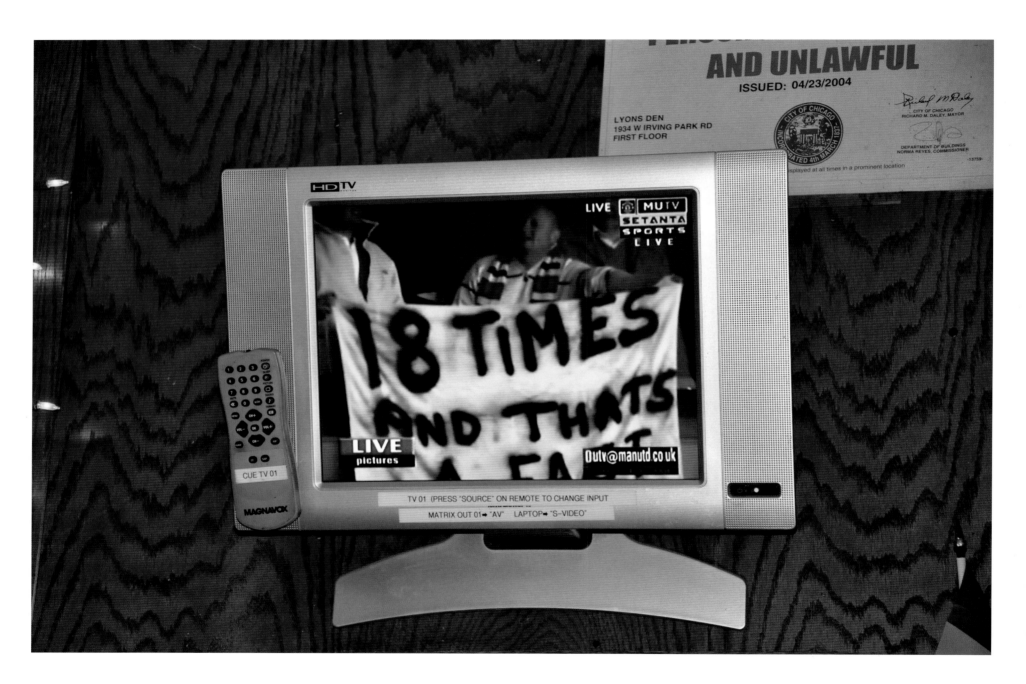

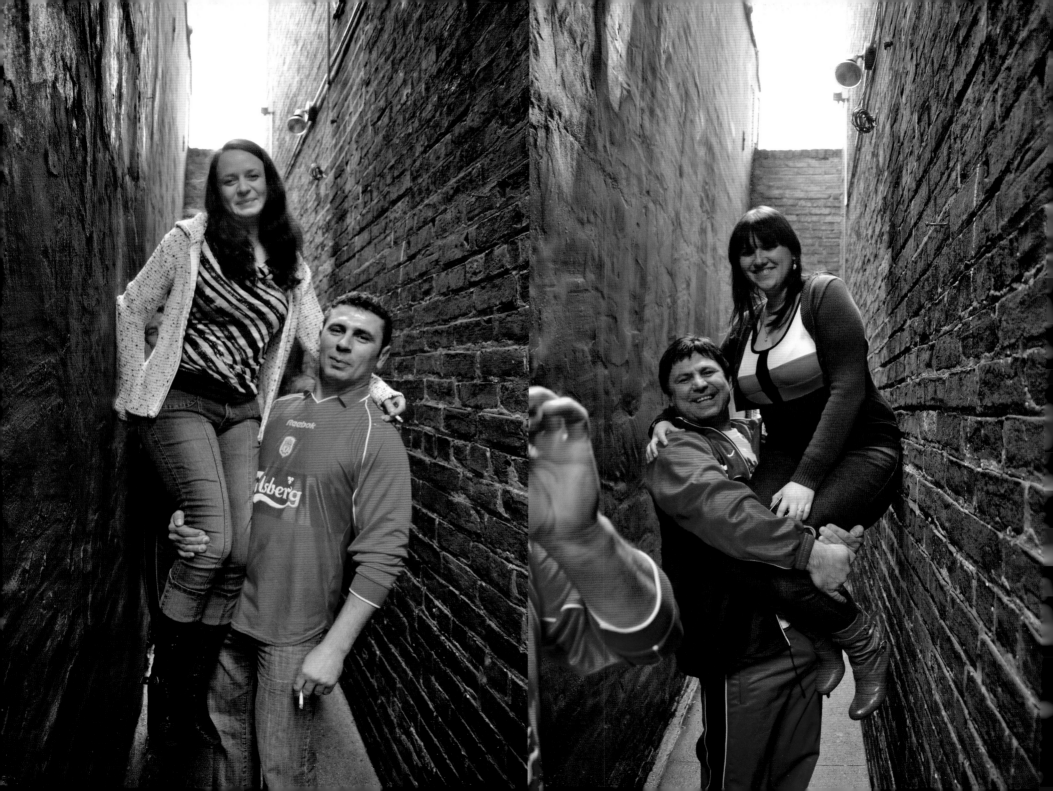

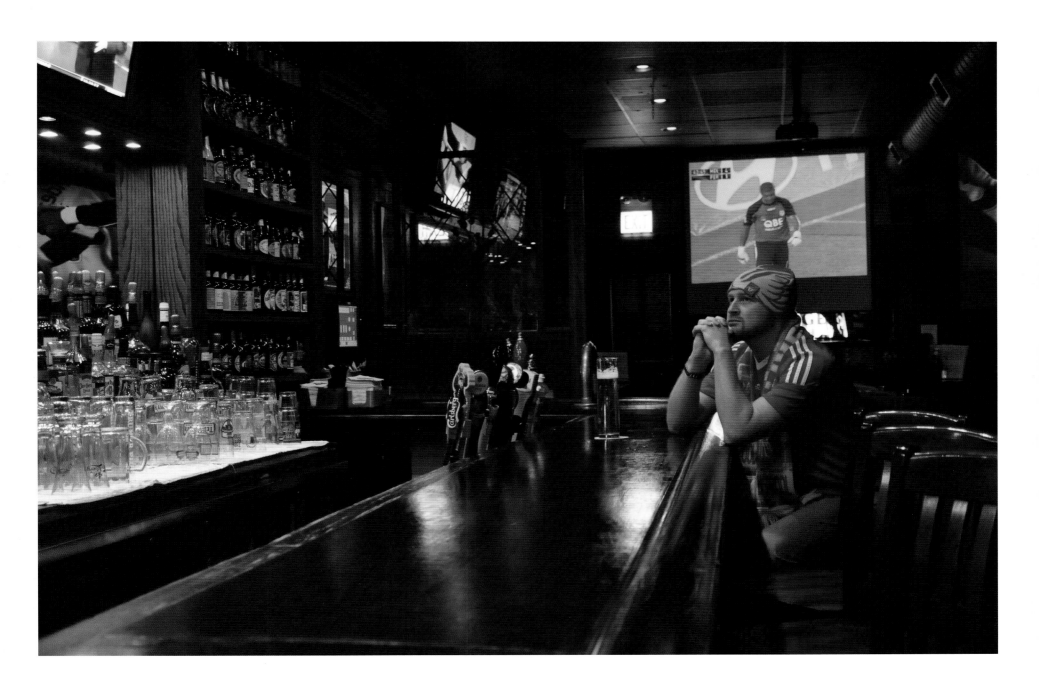

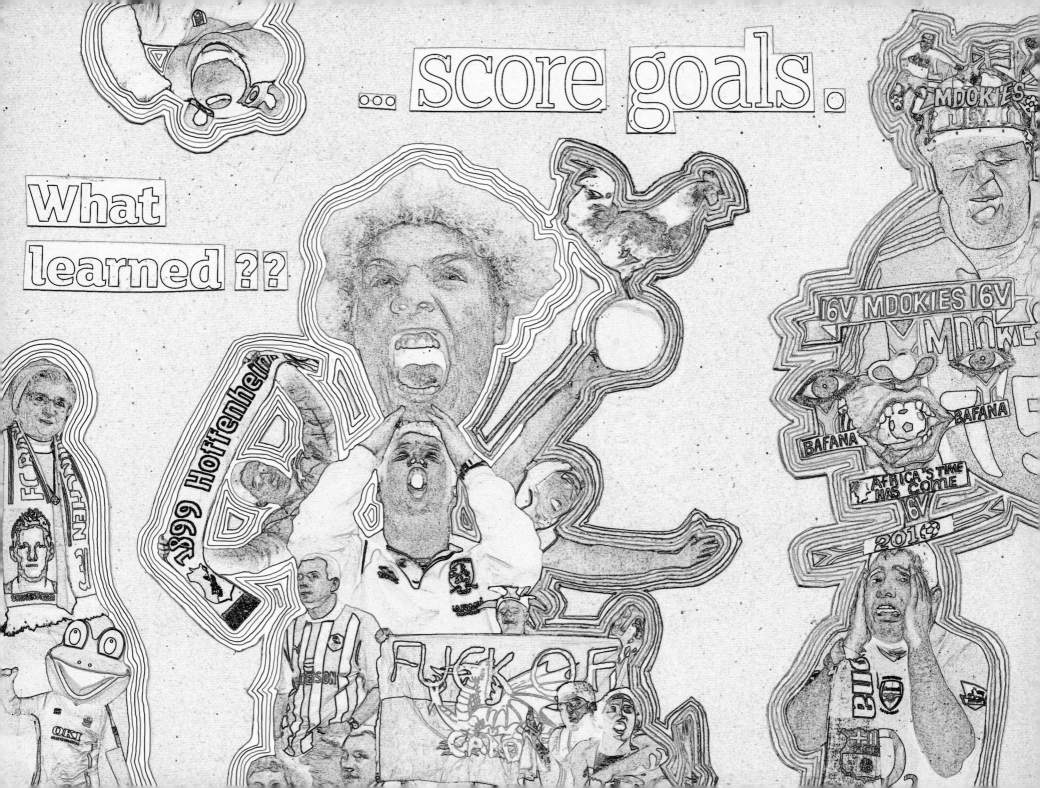

Post-match Analysis

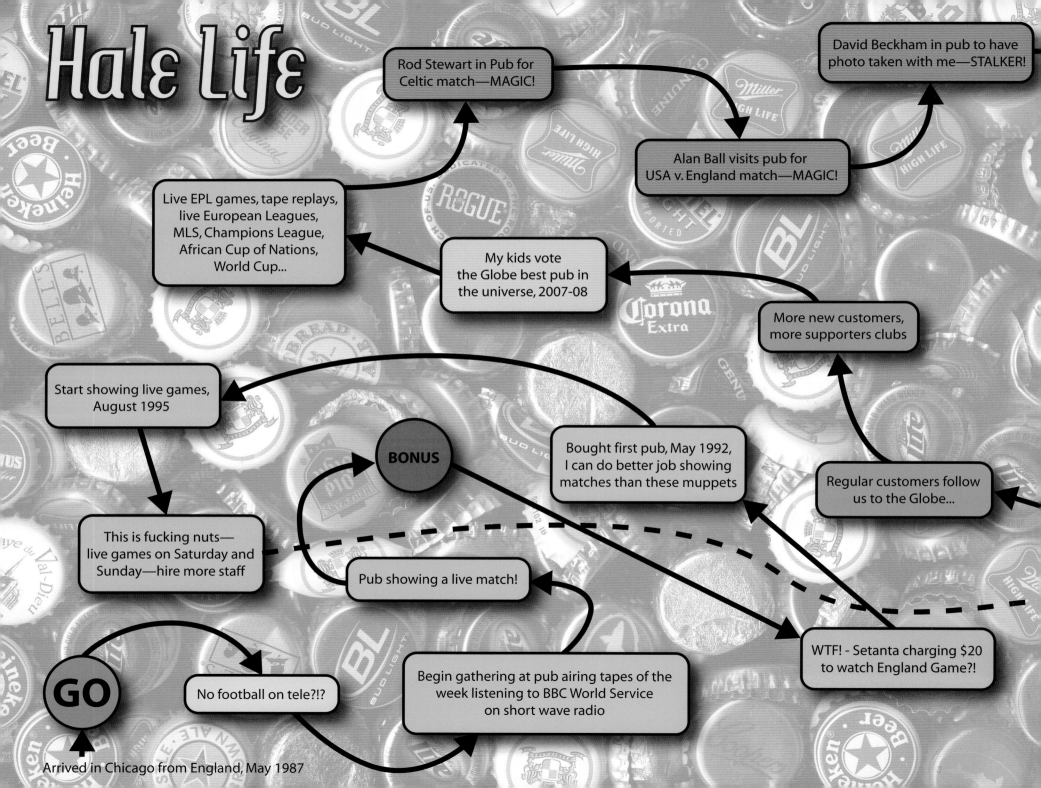

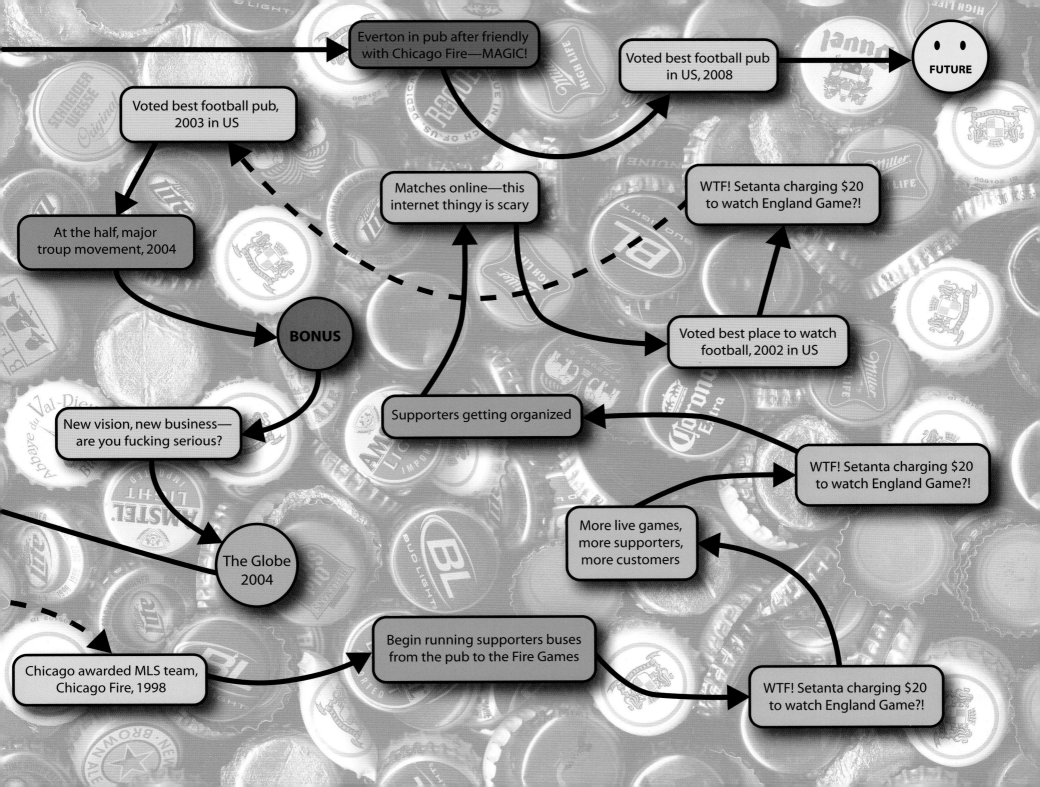

Everton in pub after friendly with Chicago Fire—MAGIC!

Voted best football pub in US, 2008

FUTURE

Voted best football pub, 2003 in US

Matches online—this internet thingy is scary

WTF! Setanta charging $20 to watch England Game?!

At the half, major troup movement, 2004

BONUS

Voted best place to watch football, 2002 in US

New vision, new business—are you fucking serious?

Supporters getting organized

WTF! Setanta charging $20 to watch England Game?!

The Globe 2004

More live games, more supporters, more customers

Chicago awarded MLS team, Chicago Fire, 1998

Begin running supporters buses from the pub to the Fire Games

WTF! Setanta charging $20 to watch England Game?!

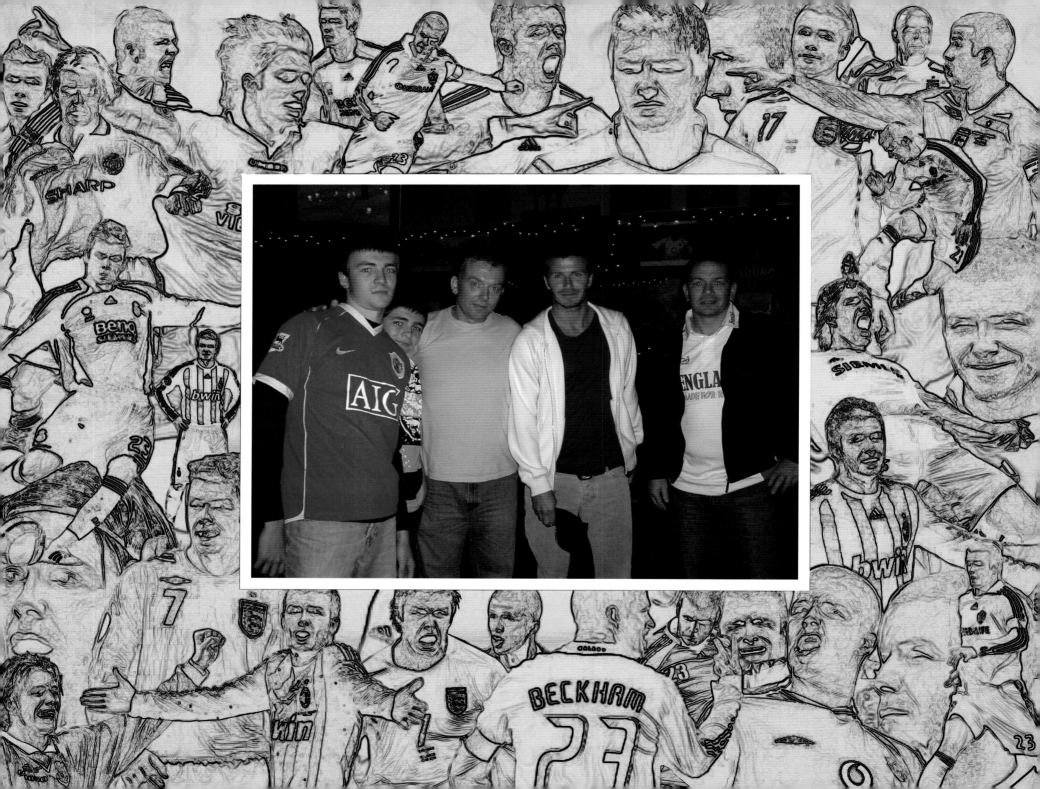

**AMESON**
®
**IRISH WHISKEY**

**BUSHMILLS**
**IRISH WHISKEY**

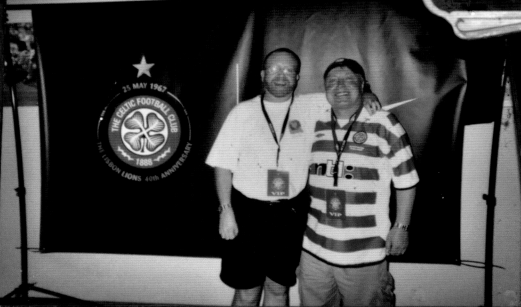

25 MAY 1967
THE CELTIC FOOTBALL CLUB
1888
THE LISBON LIONS 40th ANNIVERSARY

**The Globe**

It's perverse really. Your eyes snap open at 5:30 AM on some of the most bitter and forbidding Chicago winter mornings. It's still dark and the rest of your body tells you to burrow even further into your lovely, warm bed. The radio news tells you that there's been an ice storm and the city is advising that all nonessential travel should be postponed until the roads are cleared. You may be hungover, ill, brokenhearted, newly unemployed, or just generally wretched, but none of that matters now: it's match day.

There truly isn't anyone on the roads; always a bad sign in a big city. But you slip and slide along, alternately cursing, as it seems more likely you won't make it before kickoff, and consoling yourself that there will be plenty of seats because no one else is stupid enough to be out in this weather. And then you see them. One or two solitary figures in dark hoodies and layers of winter gear, all stumbling along in the same general direction. They could be anybody. They don't even look human, bundled up and shuffling along that way, more like something out of a low-budget zombie movie (but with no scantily-clad female victims-to-be in sight). But then you see them in clusters of two or three and, finally, the last-chance throng of smokers out in front. Someone yells "Ya scouse scum!" as you get out of your car or cross the street, and you're there.

In the door, into the lights. The room hasn't had a chance to warm up yet but it's already alive. The staff are buzzing: from the early hour, from whatever they've taken to recover from the night before, and from the realization that, yes, despite the weather, they're still going to have a full house to deal with. Not only is there an ungodly 6:15 AM kickoff, but a 6:45 AM start as well. And the supporters have to be sorted out: Arsenal in front; Liverpool in back. And someone's called in about the Celtic match; which screens shall that go on? And can we get a computer feed for Birmingham, they may have a real chance at promotion and this could be a key game. The regulars meet, exchange pleasantries, and begin the rounds of ritual abuse that will ebb and flow between supporters' groups for the rest of the day. Drinks appear, you settle in, and the whistle blows in a time zone six hours away.

This is The Globe. After home and work, this is the "third place" in our lives, the place that keeps us civilized and sane (although some of our families and friends would argue that coming to The Globe has quite the opposite effect). For a lot of ex-pats, whether from Scotland or Senegal or Ireland or Italy, The Globe is that little bit of home where everyone who grew up with football understands and shares some part of your childhood. The Globe is also, of course, a popular neighborhood pub for after-work, before-games (Cubs and Bears, as well as Chicago Fire and Red Stars), quiz nights, or just being amongst kindred spirits at any time at all. But the devotion of The Globe to football—in terms of their commitment to showing as much football as is technologically possible, the steady stream of good service and good sense coming from behind the bar no matter how early the hour or how crowded and tense the room (Erin, stand up), and the knowledgeable, bloody-minded supporters—seems to have made the pub a sort of touchstone for both newcomers to Chicago and traveling football-lovers. The changing expressions on the faces of these disoriented transplants and overstimulated vacationeers and jaded road warriors, just before they get engulfed by the games and the banter, is a sight to behold: the arched, disbelieving eyebrow followed by the cracking veneer of cool, then the glimmer of childish glee, and...wait...Fletch scored! What time is it back home? Have to call to see if they're watching this! The slap on the back, the offer for the next round. Erm, right now, this is home.

For others like me, a generation or two removed from our immigrant parents and grandparents, The Globe helps us to become more comfortable with family quirks previously thought to be congenital social defects: eat beans with breakfast, check; imbibe Guinness or whiskey for what ails you, check; queue whenever more than three people in close proximity, check. And sometimes, if we are very, very lucky, The Globe is the place where a hitherto hidden and unique part of us finds its full expression. In my case, the family sports-madness (my aunt was buried with a Gordie Howe replica jersey), proximity to Canada and all things hockey, and the attempts of any number of early boyfriends to groom me as a Red Wings fan-ette somehow failed to have the desired effect. No, it was the breathtaking skating and style of the Montreal Canadiens of the '70s that won my heart and moved me to save up for the replica Guy Lapointe jersey, which I've carried with me for the past 40 years. "Hockey Night in Canada" ruled the evenings and weekends of my adolescence, which led to a lazy habit of watching the post-game CBC News, which then led, fatefully it seems, to seeing a brief commemorative feature on Munich and the Busby Babes. That was it. Although it was nearly impossible to see anything more than a few football highlights on U.S. or Canadian television at the time, I would forever after know who I supported and why: Manchester United never gives up.

Spring at The Globe. End of the season, the windows are open, it's actually light(ish) outside no matter how early the match. Considering how bone-tired we supporters are, it's hard to imagine how the footballers must feel. You've been counting the matches left in your sleep and obsessively re-figuring the odds of your team squeaking up a notch or two in the table. Then, suddenly it seems, the season is over. Part of you breathes a sign of relief: Back to the rest of your life! Sleeping in on weekends! No more mid-afternoon hangovers! The relief wears off quickly, though, and you are soon left listless and bereft. Within a week, you're so desperate for anything to do with football that you hang on every transfer rumor, no matter how ludicrous. You relish previously laughable pre-season tours and exhibitions. You alternately cringe at and covet your club's new shirt. You cheer for your country's side during the Euro Cup or the Copa d'Oro or the World Cup. And wait for the season to begin again.

Sandra Kaminska Costello

## Early Starts and Broken Hearts: The Terrible Saga of the Chicago Chelsea Supporters Club

There are certain aromas that when encountered evoke strong feelings and associations in the person who inhales them. The slightest waft of a fragile, delicate perfume enlivens the senses and can almost crush a man with its femininity, especially if the guy hasn't smelled any for a while. The smell of bread baking brings forth long-forgotten connections with safety, well-being, and parental love. And napalm, as Robert Duvall's character Lieutenant Colonel Bill Kilgore, in the movie *Apocalypse Now*, enlightened us, "smells like victory."

So it is with The Globe. This hole-in-the-wall-type bar, which before the expansive renovations, you could barely see into (like the singularity of a black hole, you could make out furtive movements and nothing else), has become a light, airy Mecca for followers of the beautiful game in Chicago and beyond. My irregular weekend pilgrimages to this, the home of football, will always be associated with the smell of a bar at opening time. The particularly heady fragrance of a combination of cleaning fluids, old beer, and (before the ban) stale cigarette smoke would be considered anathema by many but, to myself and others, it is the aromatic primer that precedes a morning of shenanigans.

Due to the time difference, watching the EPL in the United States is a labor of love. It involves forsaking all others, committing to the game and fellow supporters alike, and the abandonment of all other activities for the day that don't involve the word "pint." The early games are, on the face of it, screened live at an extremely inconvenient time. But what, as a supporter, are you supposed to do? Sit at home like Billy-no-mates? Or drag your carcass up to The Globe and make a day of it? If you really have to think over that dilemma, give yourself a slap.

I have found myself at The Globe with the other handful of Chelsea supporters, jostling for position, eschewing coffee and breakfast sandwiches, and going straight for the golden Carlsberg jugular at some ungodly hour of the morning. We have sung, we have heckled, and we have directed some good-natured abuse at fans from just about every other team in the EPL for what seemed a lot longer than the regulation ninety minutes. Our fan club has been dwarfed by the traveling circuses that are the Arsenal, Liverpool, and Manchester United supporters' clubs. On occasion, we've all been in The Globe at the same time (you show me anywhere in England that can boast that) but our small, flag-bearing group has always stood its ground.

We've experienced soaring highs together, like the 2007 FA Cup Final victory against Manchester United. And we've suffered catatonic, despair-inducing defeats together, like the ignominious end to the 2008 UEFA Champions League Final against, yet again, the Red Devils.

We've wound people up and, conversely, suffered at the hands of the wind-up merchants, but we've always walked out of The Globe into that harsh sunlight with our heads held high. As I've wobbled off down Irving Park Road, past the normal people out with their kids and dogs, possibly getting a coffee and a paper, I've always thought I detected a little bit of envy in their eyes. Could they possibly be envious of our motley crew? We have somewhere to go next match day, people to meet, and claims to be staked. We have the EPL and The Globe, and they don't.

Jamie Michael Bradley

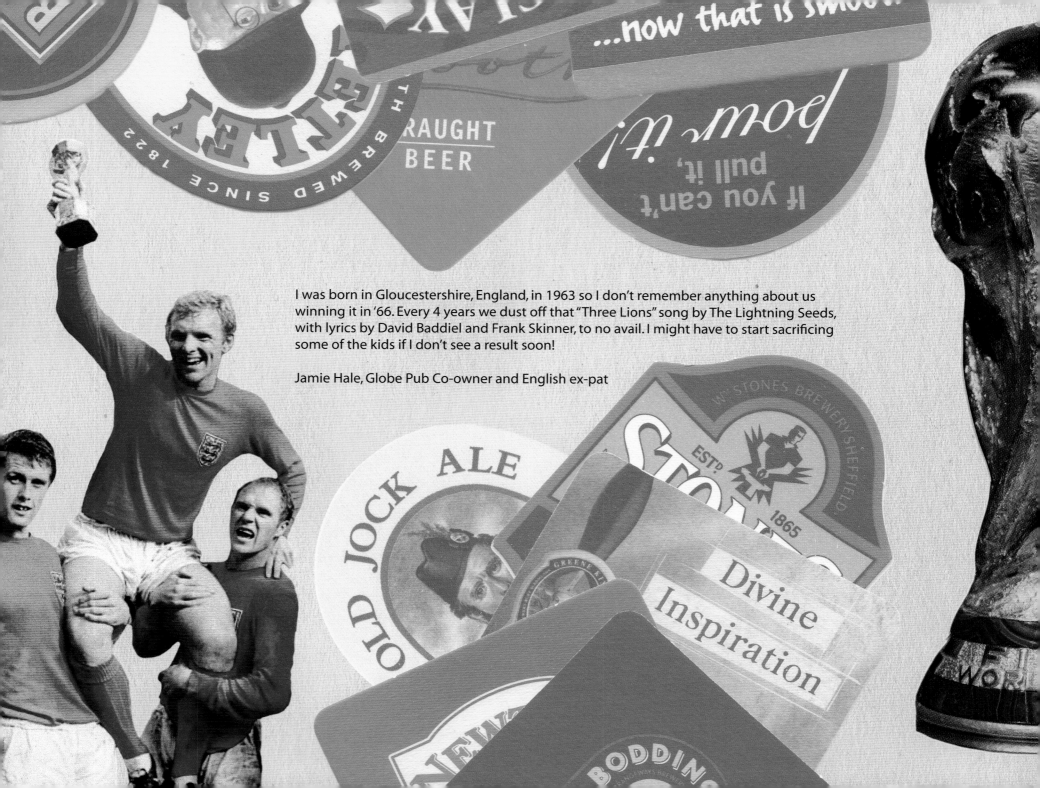

I was born in Gloucestershire, England, in 1963 so I don't remember anything about us winning it in '66. Every 4 years we dust off that "Three Lions" song by The Lightning Seeds, with lyrics by David Baddiel and Frank Skinner, to no avail. I might have to start sacrificing some of the kids if I don't see a result soon!

Jamie Hale, Globe Pub Co-owner and English ex-pat

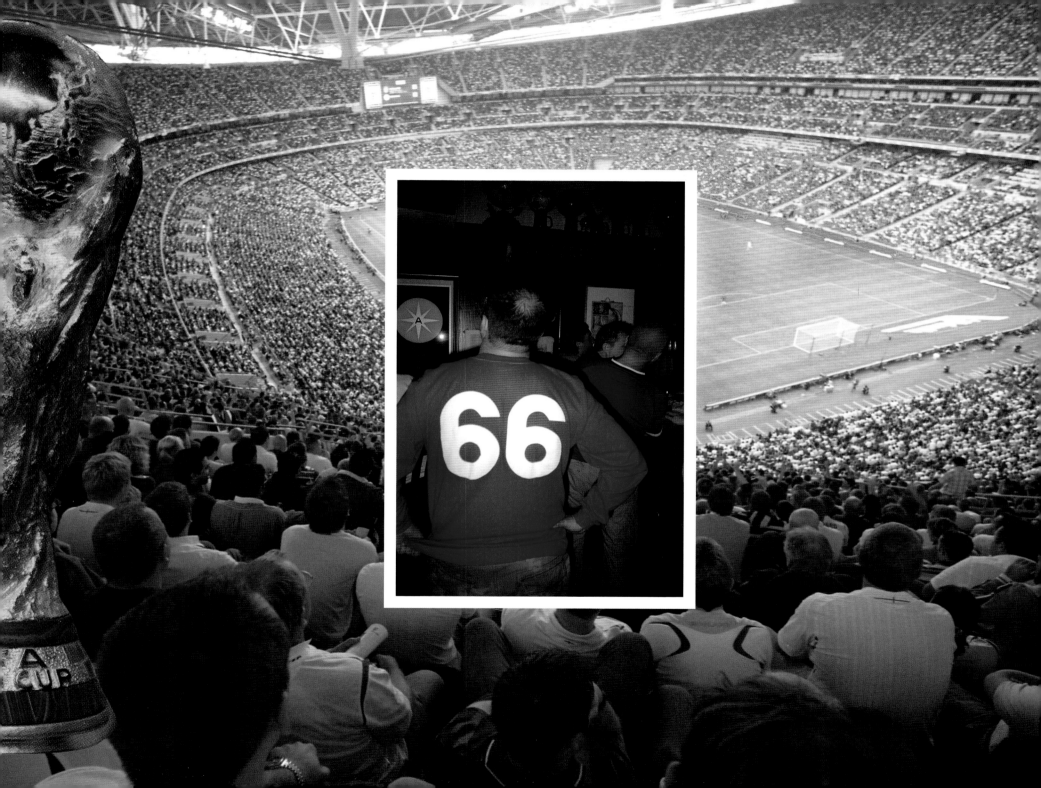

SA 2010

**Afterword**

Since opening in 2004, literally thousands of football fans have come through our doors (some are still trying to find the way out).

Before The Globe, I never realized what a varied skill set was required to run a football pub: marriage counselors to wives and girlfriends who can't understand their partner's preference for a pub at 6 AM on most weekend mornings; friend to a first-time visitor wearing a Reading shirt, who is engulfed by a bar full of tattoo-covered Arsenal fans; chief cook and bottle-washer to supporters stumbling in as early as 6 AM or as late as 1 AM, who need some solid food to sober them up sufficiently to watch the game; a shoulder to lean on when your team is robbed of a victory; a back to jump on when your team scores a great goal; and a diplomat when club rivalries threaten to get out of hand. Oh, and then there's the business side of it....

These photographs give you some idea of why we're happy and proud—despite the wear and tear on our minds, bodies, mental health, hairlines, and pocketbooks—to provide a home for a wonderfully diverse crowd who all come together to share their love of the beautiful game.

I hope you come in and join us for a match soon. If you remember to bring us a scarf to put up on the wall, I'll be sure to buy you a pint!

Cheers!

Stuart Johnston

## Image List

Images are titled according to a specific football fixture held between 2006-2010, unless otherwise indicated. Please note that games are not listed chronologically.

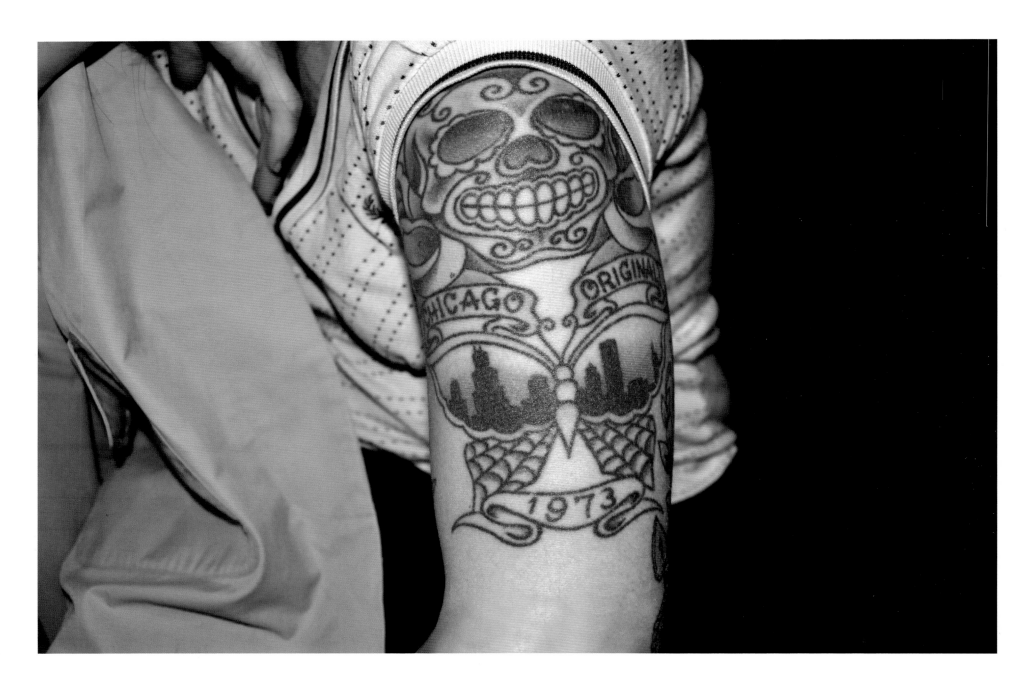

## Contributors

Jamie Michael Bradley was born in Kidderminster, England. Since 2005, Bradley has lived and worked as a writer in Chicago. Bradley's favorite football memory (by far) had to be managing The Globe Pub football team to victory in the Chicago Sports Monster Co-ed Sunday League in 2007. Bradley states, "If you want to win money on a football game prediction, ignore anything I tell you."

Michael C. "Chester" Alamo & Costello has lived in Chicago since 1993. Costello grew up in Indianapolis, Indiana, and first encountered football via a delayed replay of the 1986 FA Cup Final between Liverpool FC and Everton (3-1). His favorite football memory is being hoisted into the air by a group of LFC supporters from Albania at The Globe Pub when Liverpool won the 2005 Champions League final in Istanbul, Turkey.

Sandy Kaminska Costello grew up in Detroit and has lived in Chicago since 1990. One of her favorite football memories was at the Globe in April 2007, when United came back in the second half of an away fixture at Everton to take the title out of Chelsea's hands; the ripple of energy and momentum as it shifted from the Chelsea end of the room to the United end was almost palpable—and thanks in part to her boy, Wayne Rooney.

Aaron Patrick Flanagan is a poet, writer and educator living in Chicago. Born and bred in West Virginia, Flanagan was introduced to the sport of football (soccer) in a similar, painful manner endured by many American youth of his generation.

John Goodwin was born in Islington, London, England. In 1973, Goodwin moved to the United States. His favorite football memory is the time he stood on the terraces at White Hart Lane behind the Spurs goal when Ray Kennedy headed the winner on that "magical" night in May 1971. With this victory, Arsenal went on to win the first half of their double that day.

Jamie Hale served in Her Majesty's Royal Navy from 1979 to 1987, prior to opening The Globe Pub with Stuart Johnston in 2004. Hale was born in Gloucestershire, England, and his favorite football memory is created every time Everton beats Liverpool FC.

Stuart Johnston was born in Irvine, Scotland, and has been a Celtic supporter ever since he can remember. Prior to moving to the United States in 1992 and opening The Globe Pub, Johnston worked as a consultant for Andersen Consulting (Accenture). His favorite football memory is attending the 2003 UEFA Cup Final between Celtic and Porto held in Seville, Spain.

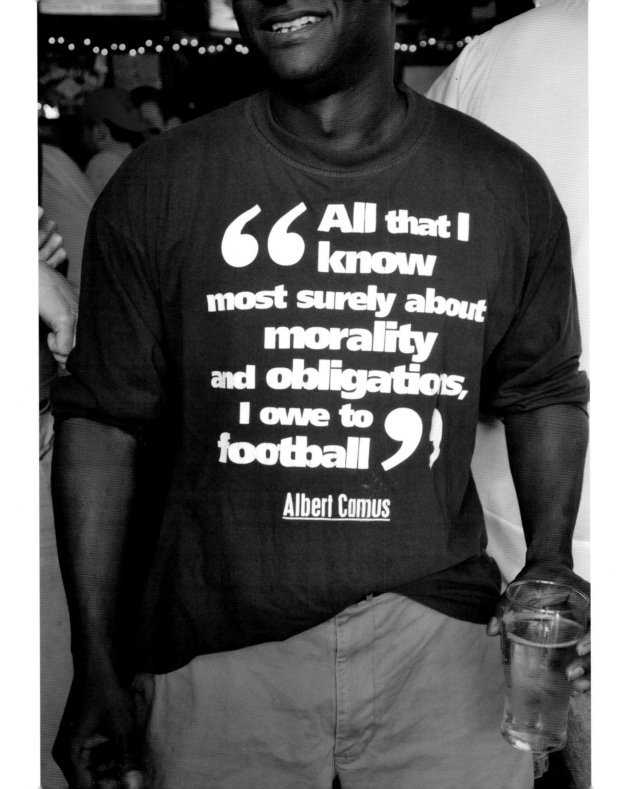

## Acknowledgments

I want to begin by thanking Jamie Hale, Stuart Johnston, and Gary Winters for all of their assistance and patience in realizing this effort. Jamie, Stuart, and Gary have not just created a place that is a true "total football" destination, but a second home for Sandy, me, their motley crew of ex-pats, and Yanks who've realized that football (soccer) is a reflection of everyday life.

For offering a piece of their connection to the "beautiful game," their written contributions, and honest appraisals of The Globe, I thank Jamie Michael Bradley, Sandra Kaminska Costello, Aaron Patrick Flanagan, and John Goodwin. Without their essays, this project would only be partially complete. In addition, I want to thank Christine DiThomas for her assistance with copyediting and Joseph Pavlik for his assistance in the design and maintenance of the Dark Lark Press website.

For reviewing this effort while in-progress, I thank Euan Hague, Dominic Molon, and Aleksandar Hemon. Their status as true football supporters and their frank assessments are inspirational and greatly appreciated.

To all of you regulars and football aficionados who show up in the early hours of the morning during those brutal February mornings to catch a 6:45 AM kick-off, I thank you for reminding me that a little insanity can be a healthy dose of reality. Specifically, I wish to thank Mike "Boydo" Boyd, Maureen Mullen, Lara Hayes, "Staircase" Dave Coulthard, Alun "Blue Nose" Childs, Deborah "Spot" Kash, "Smooth" Martyn Wilson, Marc O'Sullivan, Jim Wright, Andy "The Hammer" Maitland, Adam "The Canary" Ridgewell, Simon "Les Muscles" Burke, Brian Robson, Iain "Hotspur" Williams, Harold Share, Michael Verscaj, Jim Comerford, Aimee Frances Warshall, Matt Jaeky, Dan Hutchins, "Traveling" Sean Mulkeen, Joseph "The Yid" Tomlinson, Carolyn Verscaj, "Irish" Stephen Piggott, Chase Browder, Vasil Simeonov, John Howard, Andrew Howard, Chris Howard, André "The Jamaican" Wrighte, Anthony Marco, Georgiy "Little Russian" Dzhakoniga, Michael "Big Russian" Kechker, Aniruddha Tapis, Dan Skinner, "Cambridge" Chris Liebelt, Henry Jankowski, Quentin Turner, Monte Householter, Dale Glen, "Liverpool" Dave Kelch, John Fenton, John Koutoupis, Adrian Mathews, Melissa Severin, Kevin Achettu, Bryn Griffiths, Dari "The Red Albanian" Mertiraj, Afrim Balliu, Heladon Dajci, Viktor Golemi, David Voynovich, Chris Brady, David Lifton, Joe Silva, Eric Davenport, Al'an Blasio, Remi Soyode, Alfredo "El Tigre" Gomez, Melissa Hencke, "Dodgy" Andy Hughes, Michael Goldenberg, Phil Hodgson, Melissa "The Laugh" Heyne, Mike "The Greek" Fotopulos, Ryan Jackson, Kevin J. Beckering, Alfonso "PSG" Mitchell, "Chanting" Shane Schubbe, Lucky Momoh, "Arsenal" Rich Balabuszko, Brian "The Gunner" Doherty, Martyn "Black Cat" Pickering, "Sunderland" Eric Ward, Niall Little, Alan Goldsmith, Asa Goldsmith, Daniel McLaughlin, Padraig Garvey, James Ruddy, Doug Stepnicka, Tony Houston, Colm McCann, Dave Capp, Jon "Guanty" Guant, Casey Sachen, Karrie Figiel, Ian McNally, Diana Salisbury, Nathaniel "Monterrey" Castro, Armando Acebedo, Agustin Alonzo, Isaac Castro, Carlos Clavijo, Tom Burtonwood, Holly Holmes, Fritz Mbome, Lanré Gaji, Sanjay Sharma, Linda Nguyen, Erin Batchbelder, Kathy Kelly, Maureen Dwyer, Pat "Section 8" Stanton, Keriann Kramer, Aleksandra "Milano" Gjelevska, Doug Mraz, Anjan "Barcelona" Mukherjee, Colin Daniels, and "Cutthroat" Joe Ince, for offering their candid conversation, frequent vulgar verse, and occasional "friendly" hand gestures.

**Published 2010**
First Edition
Printed in edition of 2,000

**Dark Lark Press, L.L.C.**
P.O. Box 6923
Chicago, Illinois 60680-6923
United States of America
www.darklarkpress.com

Copy Editors: Sandra Kaminska Costello with assistance by Christine DiThomas

Dark Lark Press, L.L.C. Website: Joseph Pavlik @ Exit 236 Studio

ISBN: 978-0-615-33941-2
Library of Congress Cataloging
Publication Data Available on Request

09 08 07 06 05 04 03 02 01 00
10 9 8 7 6 5 4 3 2 1

Printed in Korea